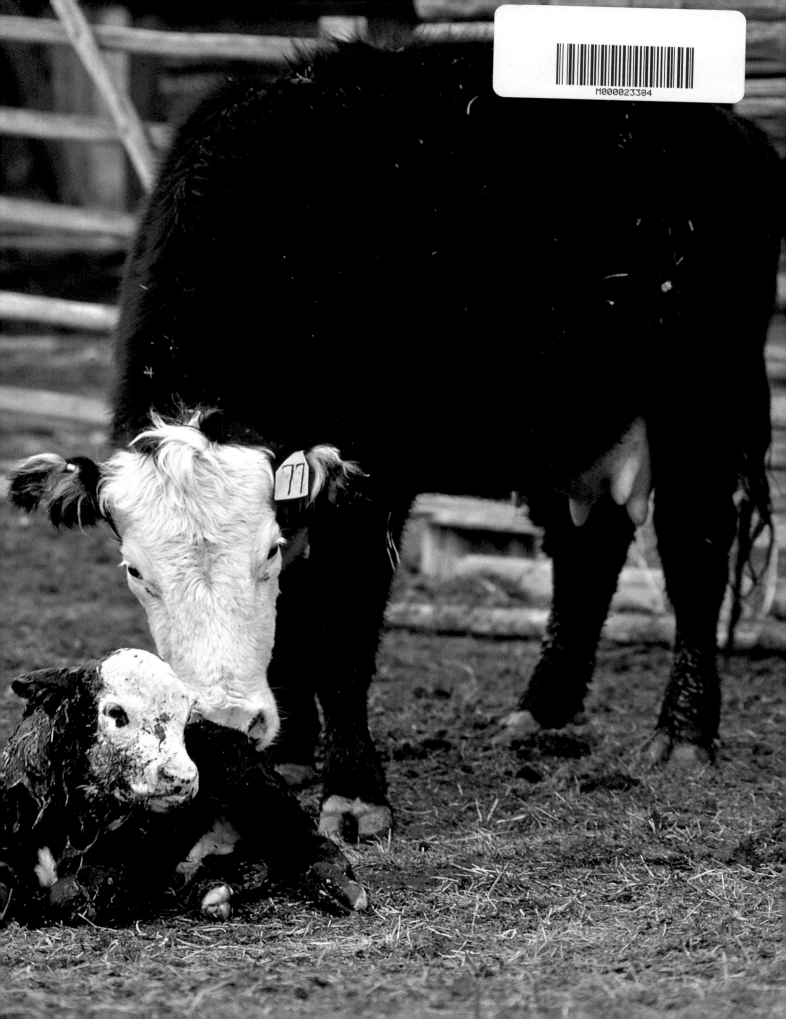

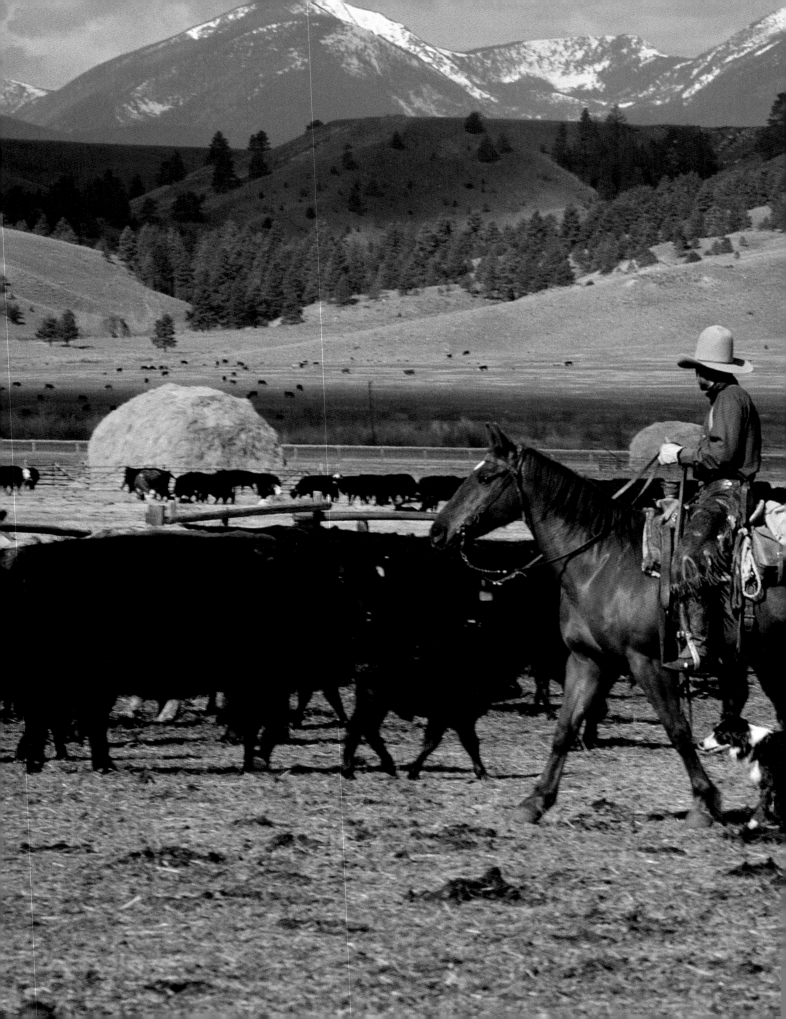

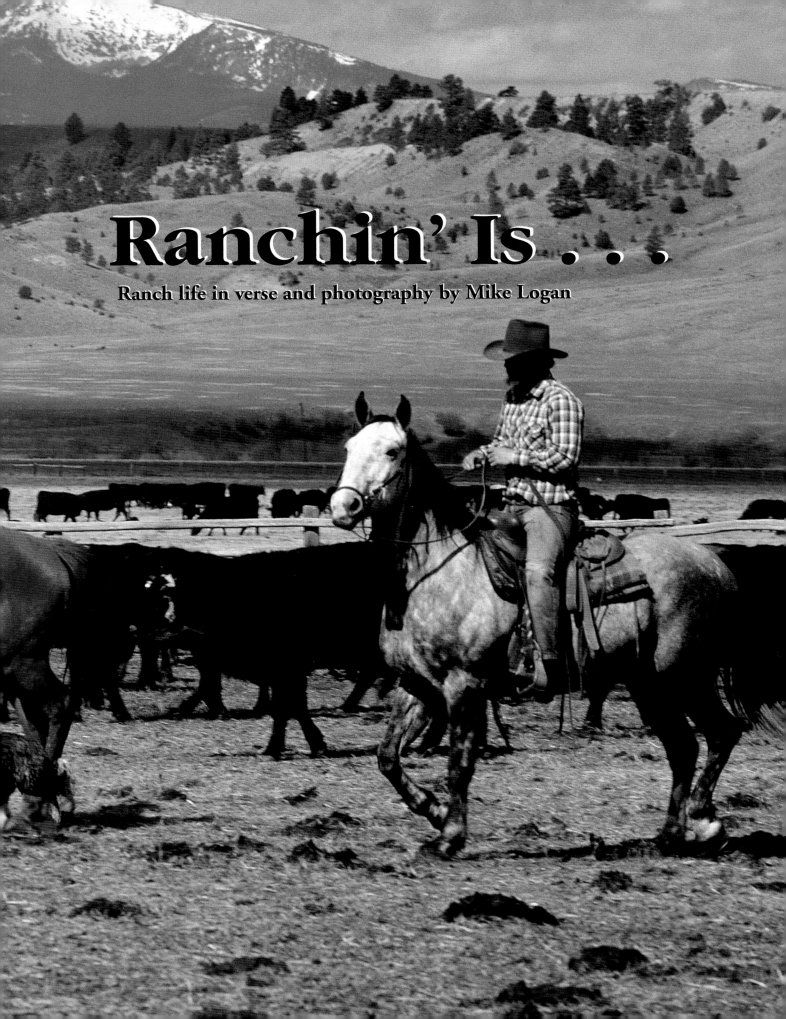

Ranchin' Is . . .

Ranch life in verse and photography by Mike Logan

Ranch Truck

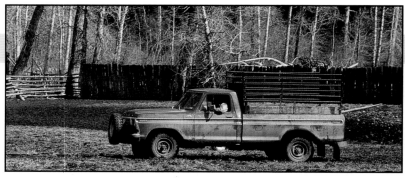

A ranch truck's like a rancher.
Don't dress up fit t' kill.
Just goes an' gets the job done
Without no pomp or frill.

While they ain't long on beauty,
Ranch trucks can hold their own.
Just see if this ol' pickup
Don't sound like some you've known.

Me an' Bruce hop in his pickup.
We got some hay to load.
He's got 'er chained on all four wheels
'Cause last night it shore snowed.

Hayhooks festoon the gearshift.
There's stockwhips on the seat.
Ol' Skipper's on the towchains
That's piled beneath my feet.

The windshield's cracked an' muddy.
I give ol' Skip a shove.
The dash wears thirteen mittens
An' one odd left-hand glove.

It also sports three hammers,
Two pairs of fencin' pliers,
A stick 'r two of kindlin'
From last spring's brandin' fires,

Five caps an' some old glasses,
A Pepsi can 'r two,
A box of mixed up nuts an' bolts
An' one old work horse shoe.

There's binder twine an' ear tags,
Some string wound on a spool,
A can of pills for calf scours
An' a new ear taggin' tool,

A shot 'r two of Longicil,
A length of rawhide thong,
A pair of ancient channel locks,
A tape just ten feet long,

A crescent wrench, a pill gun,
Band aids, a chain saw file,
Three scarves an' one old down vest
All wadded in a pile,

Six washers on a twist of wire,
Eight cents in cold hard cash,
A clevis, a direction book,
An' that's just on the dash.

Between us there's two sacks of cake,
Three jackets an' some chaps
A slicker an' a Swede saw
An' three new leadrope snaps.

The floor holds one old halter,
An ax, two pairs of spurs,
A head stall an' two oil cans
An' a blanket full of burrs,

Some gunny sacks, a brandin' iron,
A brand new ropin' rope,
A pair of irrigatin' boots
An' a bar of Lava soap.

No tellin' what's behind the seat.
I'm sure ol' Bruce cain't say,
But we won't worry 'bout what's there
'Cause it ain't in the way.

We lost a tally book last week.
I'm 'fraid we're out of luck.
It's prob'ly lost forever
In Bruce's ol' red truck.

Sound like I'm knockin' Bruce's truck?
Well, that'd be plumb mean.
'Sides, we thought of usin' my rig,
But it ain't half that clean.

By Mike Logan
from *Laugh Kills Lonesome & Other Poems*

Ranchin' Is...
Copyright ©2000 by David Michael Logan

All rights reserved, including the right to reproduce
this book or any part thereof in any form, except for
inclusion of brief quotations in a review.

Published by Buglin' Bull Press,
32 S. Howie, Helena, MT 59601

ISBN 1-58592-091-6

Library of Congress Catalog Card Number: 00-133187

Design by Laurie "gigette" Gould.
All photography by Mike Logan except where noted.

Publishing consultant and production by
Skyhouse Publishers, an imprint of
Falcon® Publishing, Inc., Helena, Montana.
Printed in Korea.

Front cover photos: old Cogshall saddle; Fred Benson,
Deer Lodge, MT; Fred and Bill Murphy brandin';
Gayle Tomlinson, Deer Lodge, MT
Back cover photos: Bruce Benson, Avon, MT; horseman's
rest, Avon, MT; Chuck Gilman, Garrison, MT; Bruce and
Val Benson, Avon, MT

Buglin' Bull Press
32 S. Howie, Helena, MT 59601

4

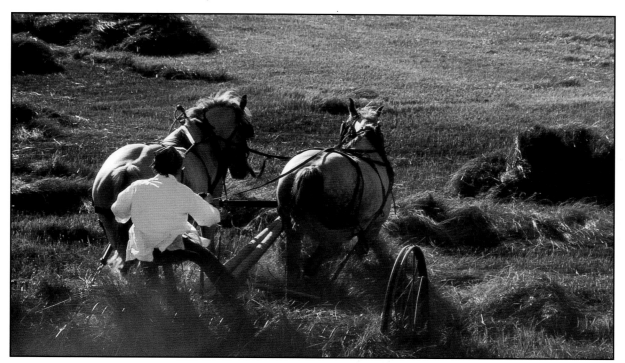

The Sundown Team

Dedication

This book is dedicated to ranch families all over Montana and America and to my friends
in the Little Blackfoot and Deer Lodge valleys in particular.

There are no finer people in the world.

Introduction

"Hey. "

I looked up to see who was yelling and the train was on me. . .

Since that summer day, I've often kidded Deer Lodge rancher Fred Benson that his shout saved my life.

The wind was howling up the Little Blackfoot River.

The train was screaming down the valley, into the gale.

Photographing the big teams and the high-poled beaverslide stacker, I hadn't seen or heard the danger roaring at me. Luckily, Fred had seen and, "Hey. . . . "

I've always said the train would have missed me. I was standing just barely off the tracks. It would have been such a near thing, though, it probably would have scared me to death.

A year and a half later I met Bruce Benson, Fred's partner-brother. Bruce called in early December wanting to know if he could get one of my framed prints, "The Sundown Team," as a Christmas present for his wife Pauline. I had captured Pauline on a hay rake with her big team that wonderful, near disastrous day on the Little Blackfoot.

In the ensuing twenty-five years, I've tried hard not to come even remotely close to getting run over by trains, mad mother cows, or an occasional snorty work horse team.

Thousands of pictures later, I have photographed nearly everything the Bensons and their friends and neighbors do in the Little Blackfoot and Deer Lodge valleys.

I count Fred, his wife Dot, Bruce and Pauline and their daughters Ev and Val among my best friends. I feel the same about their friends and neighbors. Their get-togethers to help each other with branding, shipping, cattle drives, and the multitude of other tasks and joys and sorrows, give a pretty good picture of what ranching is all about.

If this book leans a little toward winter, well . . . , ranching in Montana leans a little toward winter.

Mike Logan
May 2000

Ranchin' Is...

A cattle drive
And rakin' hay
And mountains at the close of day.
It's stirrups high
And draft horse colts
And, rustin' brown, old wagon bolts.

It's coffee breaks.
A curlew's cry
And rock chucks watchin', way up high.
It's summer dawns,
A brandin' lunch
A rider bringin' in a bunch.

It's winter's end,
A laugh to share
And trophies at the county fair.
It's quiet times
And movin' cows
The yellow eyes of great gray owls.

It's spider webs
And trails to ride.
A flat where baby pronghorns hide.
It's happy times
And sad times, too
And tackin' on a right front shoe.

It's mother cows
And gettin' gates
And checkin' scales for shippin' weights.
It's jinglin' spurs
And lambs that match,
A muley in a sage brush patch.

It's waterin' up
And pitchin' hay
And, in a tree, a bright eyed jay.
It's mornin's cold
And baby hawks
And salt all sculpted in a box.

It's leaves of gold
And waters warm.
A puncher caught out in a storm.
It's big red bulls
And old time rakes
And lonely roads a rancher takes.

It's ridin' out
And larks that sing
And chasin' water in the spring.
It's pickup trucks
And wobblin' up
And, actin' tough, a heeler pup.

It's colt lunch breaks
A blizzard ride
And new arms on a beaverslide.
It's mother'n' up
And comin' home
And pastures where the coyotes roam.

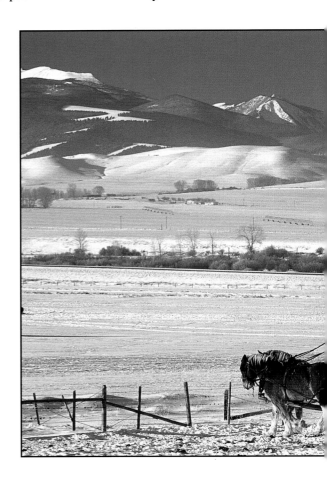

It's shippin' days
And hills to climb.
A hunter stopped to pass the time.
It's hitchin' up
A high pole gate
A ruff grouse drummin' for a mate.

It's heelin' calves
And settin' brands
And cuttin' knives in practiced hands.
It's weathered barns
A saddle bag
And, on a drive, it's ridin' drag.

It's monuments
And buildin' stacks
And drivin' in a team of blacks.
It's buglin' bulls
A rainy day.
A red fox mousin' new cut hay.

It's flowers wild
Sleigh bells of brass
And springtime with its new green grass.
It's ropin' ropes
And shotgun chaps
And, in the cold, it's winter caps.

It's jackrabbits
A final load
Across a bridge a snowy road.
It's calvin' time
Full moons at night
And valleys shinin' rainbow bright.

It's power lines
And tiny towns
And palominos, bays and browns.
It's weanin' calves
And changin' flats
And, in the sun, contented cats.

It's passin' storms
And fool grouse hens
And workin' cows in shippin' pens.
It's smokes to build
And makin' tracks
And panels 'round high mounded stacks.

It's mud and snow
And bitter cold
A Belgian burnished copper gold.
It's ranchers' sons
And ranchers' wives
And bears that raid the honeyed hives.

It's miles to ride
And work horse teams
And heifers crossin' snow fed streams.
It's gatherin'
A foggy morn
And strugglin' up a calf just born.

Ranchin' Is...

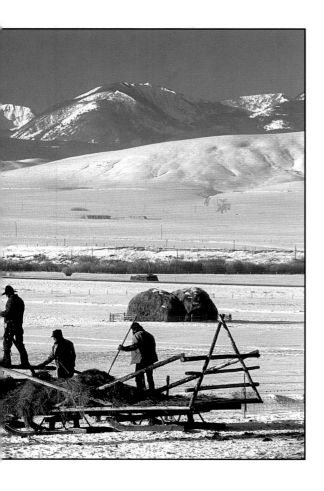

A cattle drive

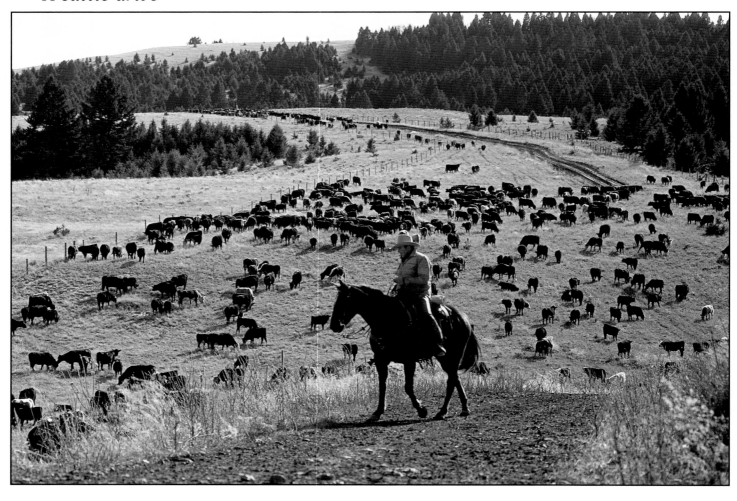

Ranchin' Is...

A cattle drive
And rakin' hay
And mountains at the close of day.
It's stirrups high
And draft horse colts
And, rustin' brown, old wagon bolts.

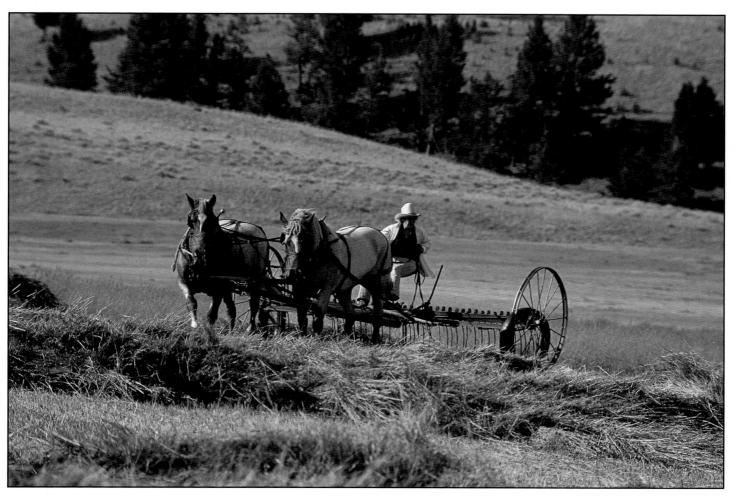

And rakin' hay

And mountains at the close of day.

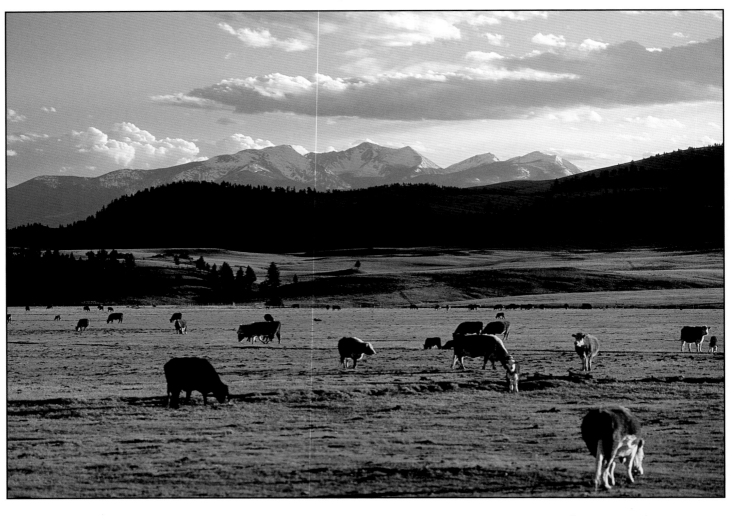

It's stirrups high

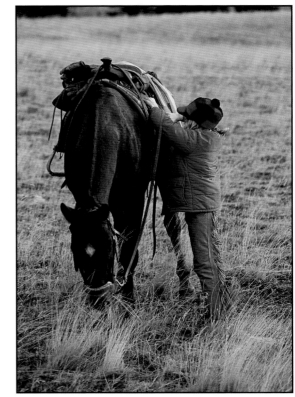

And draft horse colts

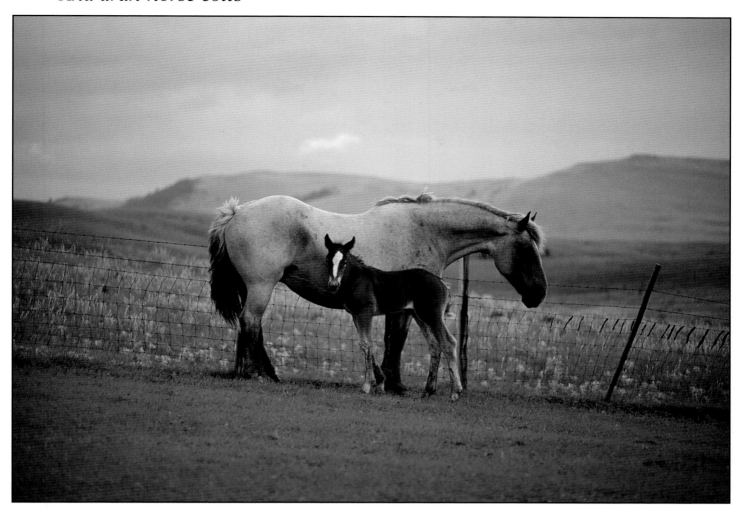

And, rustin' brown, old wagon bolts.

It's coffee breaks.

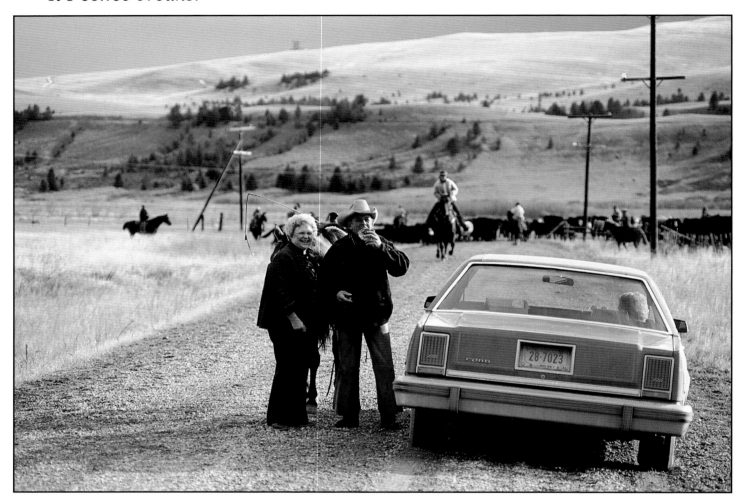

A curlew's cry

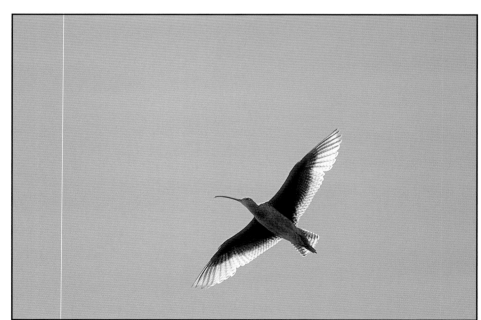

It's coffee breaks.
A curlew's cry
And rock chucks watchin', way up high.
It's summer dawns,
A brandin' lunch
A rider bringin' in a bunch.

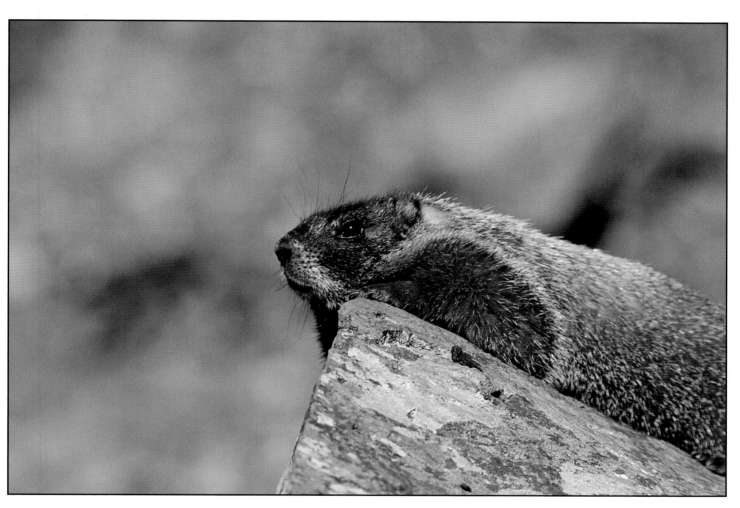

And rock chucks watchin', way up high.

It's summer dawns,

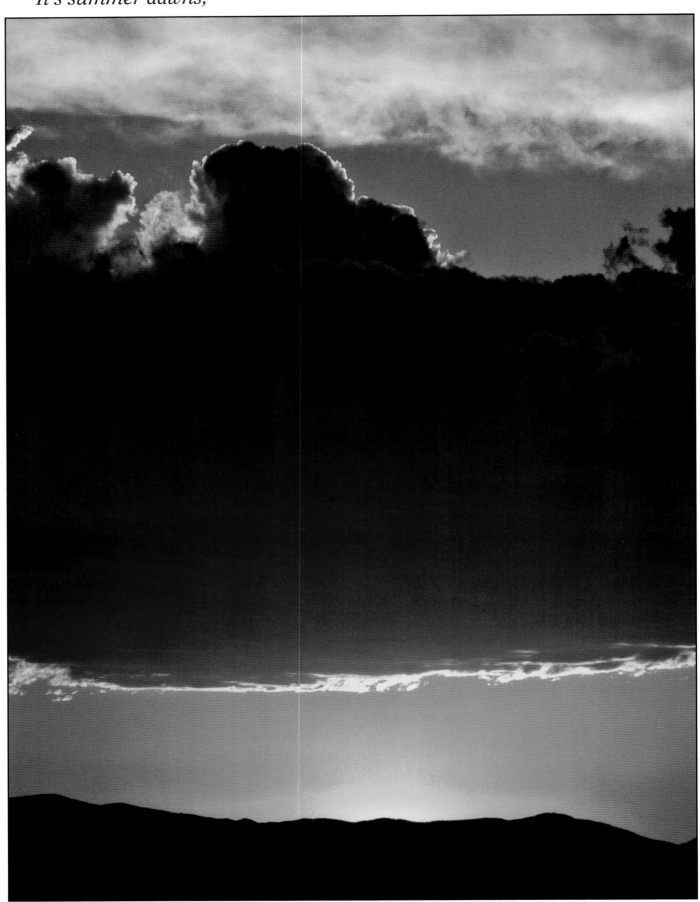

A brandin' lunch

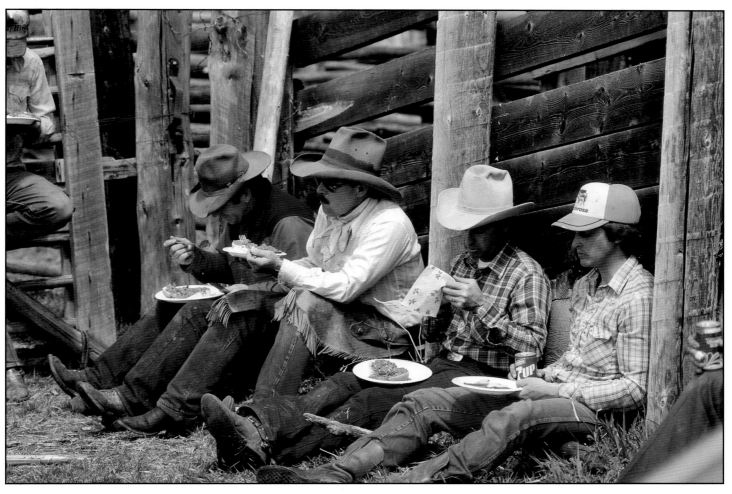

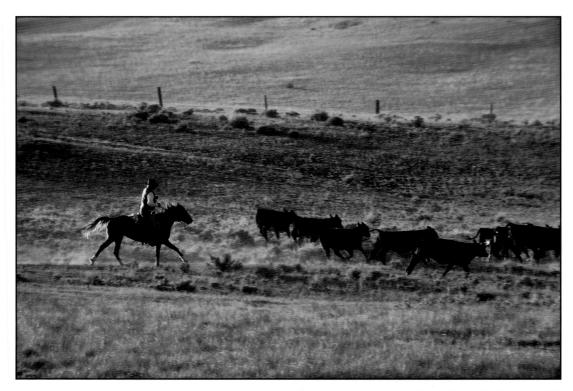

A rider bringin' in a bunch.

It's winter's end,

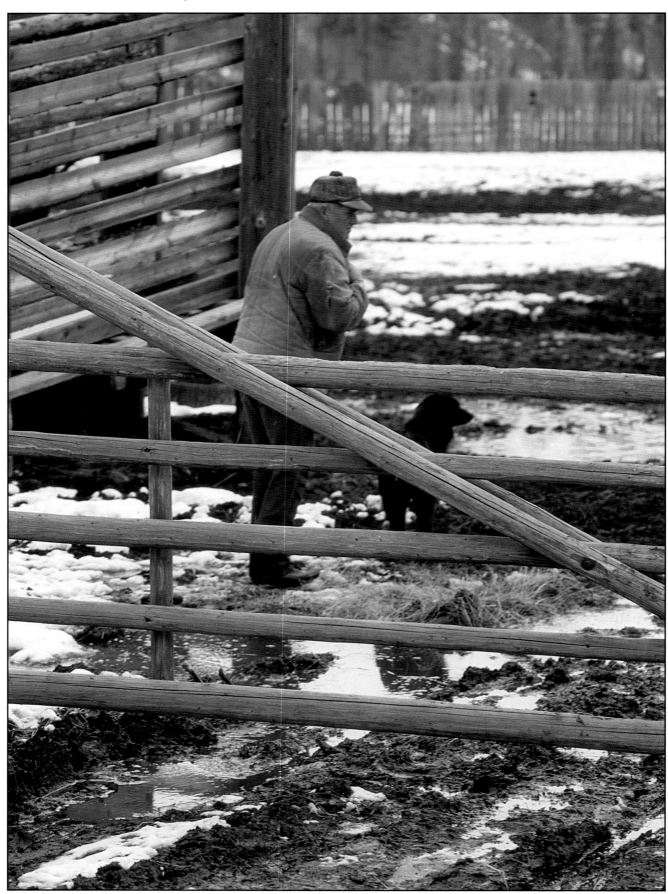

It's winter's end,
A laugh to share
And trophies at the county fair.
It's quiet times
And movin' cows
The yellow eyes of great gray owls.

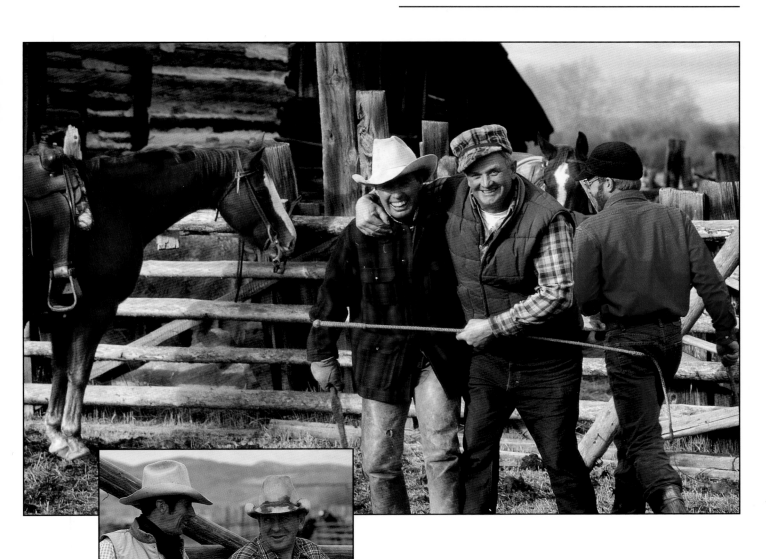

A laugh to share

And trophies at the county fair.

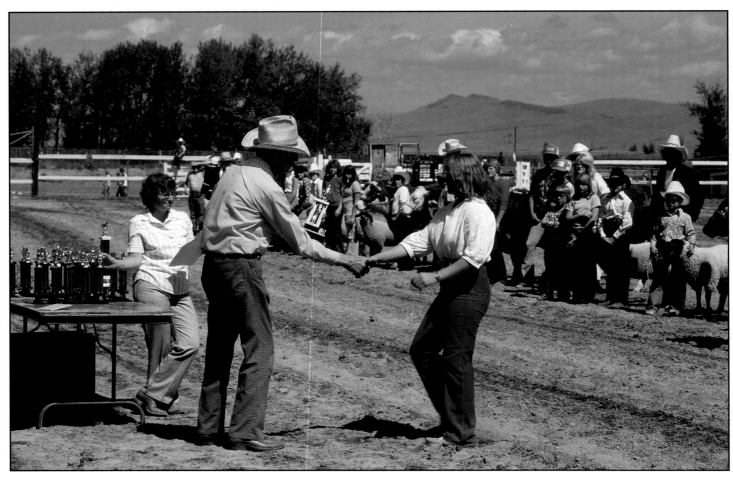

It's quiet times

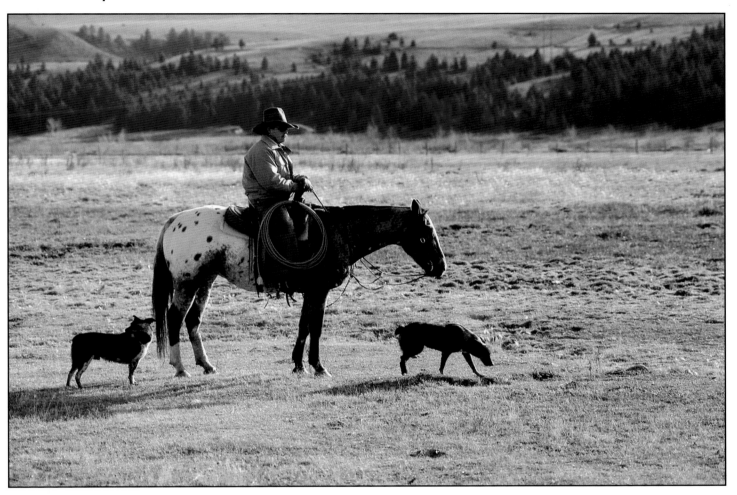

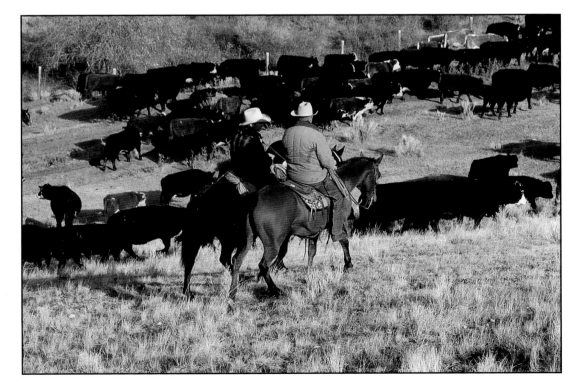

And movin' cows

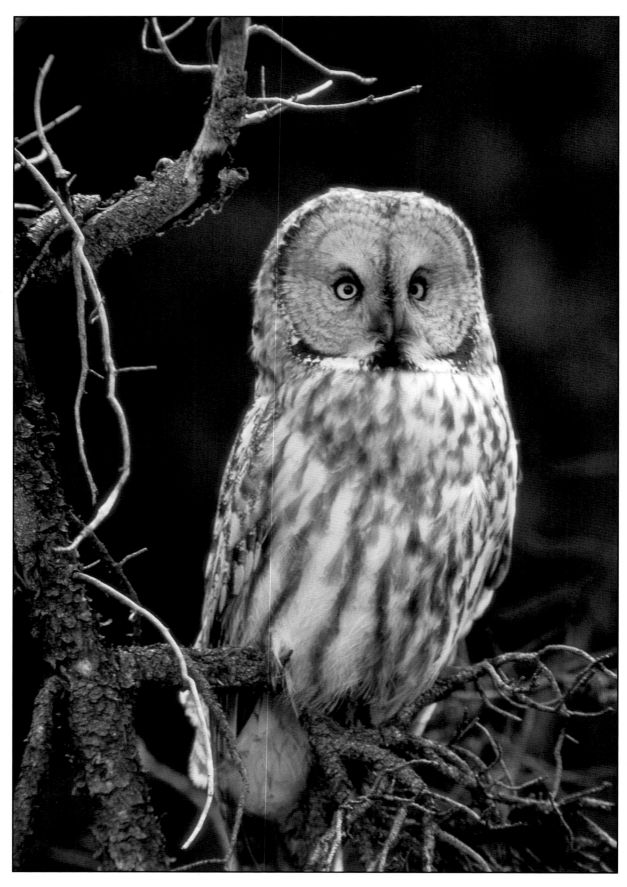

The yellow eyes of great gray owls.

It's spider webs
And trails to ride.
A flat where baby pronghorns hide.
It's happy times
And sad times, too
And tackin' on a right front shoe.

It's spider webs

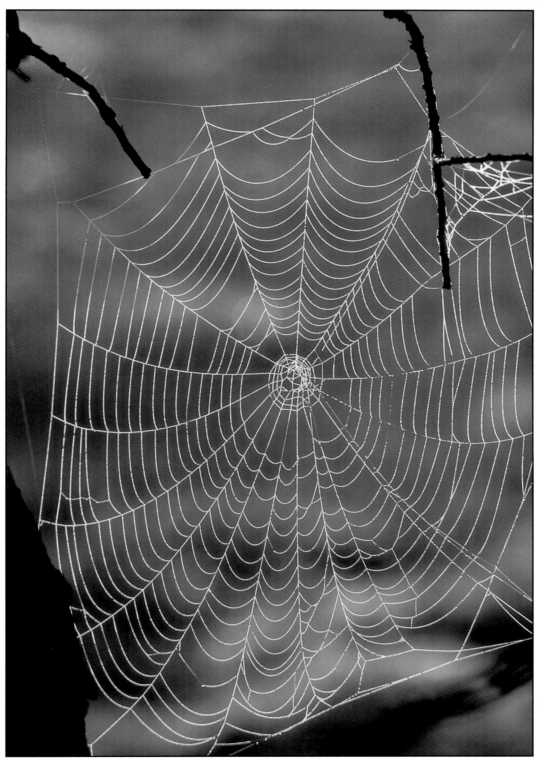

And trails to ride.

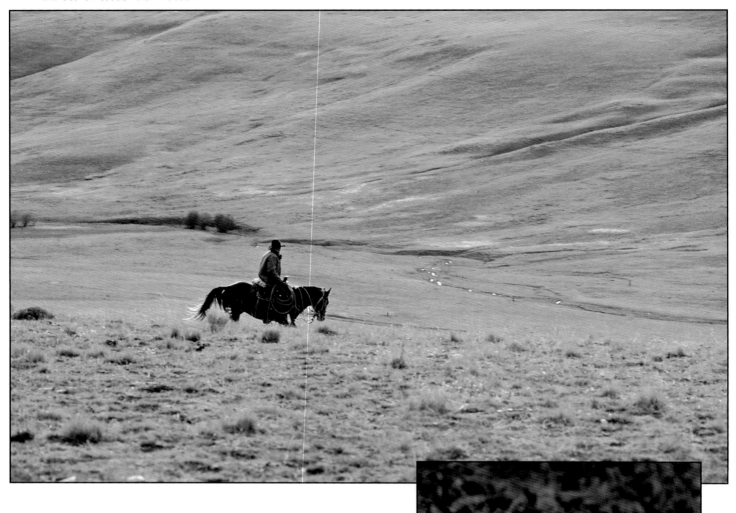

A flat where baby pronghorns hide.

It's happy times

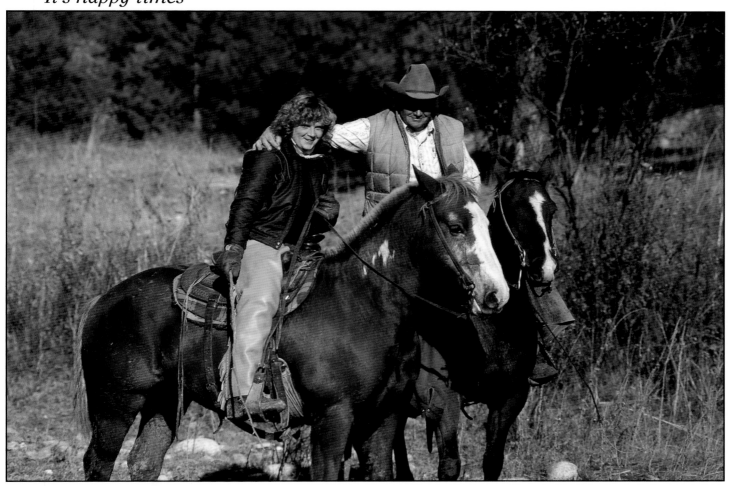

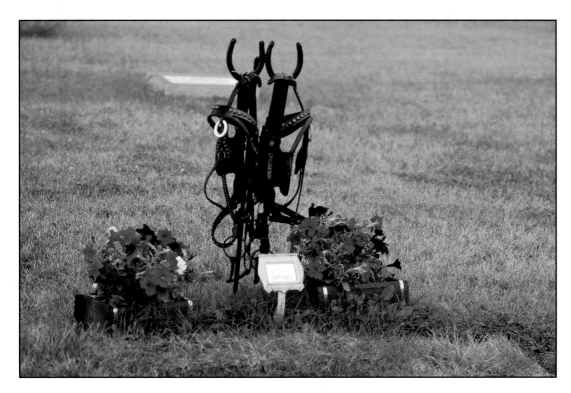

And sad times, too

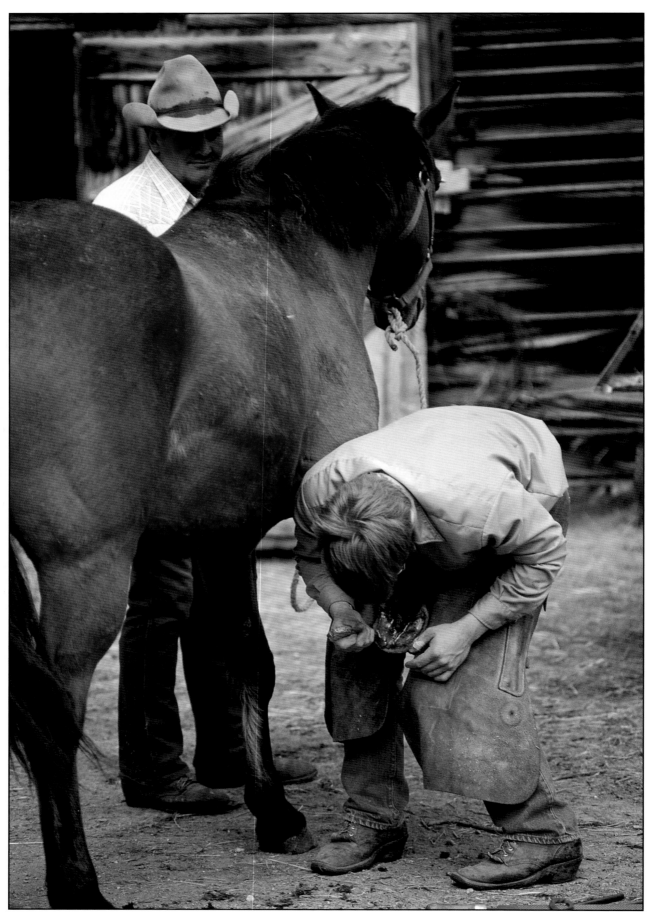

And tackin' on a right front shoe.

It's mother cows
And gettin' gates
And checkin' scales for shippin' weights.
It's jinglin' spurs
And lambs that match,
A muley in a sage brush patch.

It's mother cows

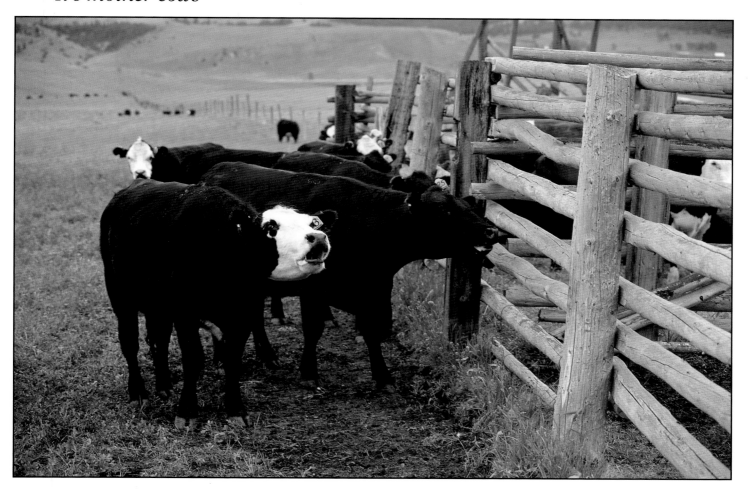

And gettin' gates

And checkin' scales for shippin' weights.

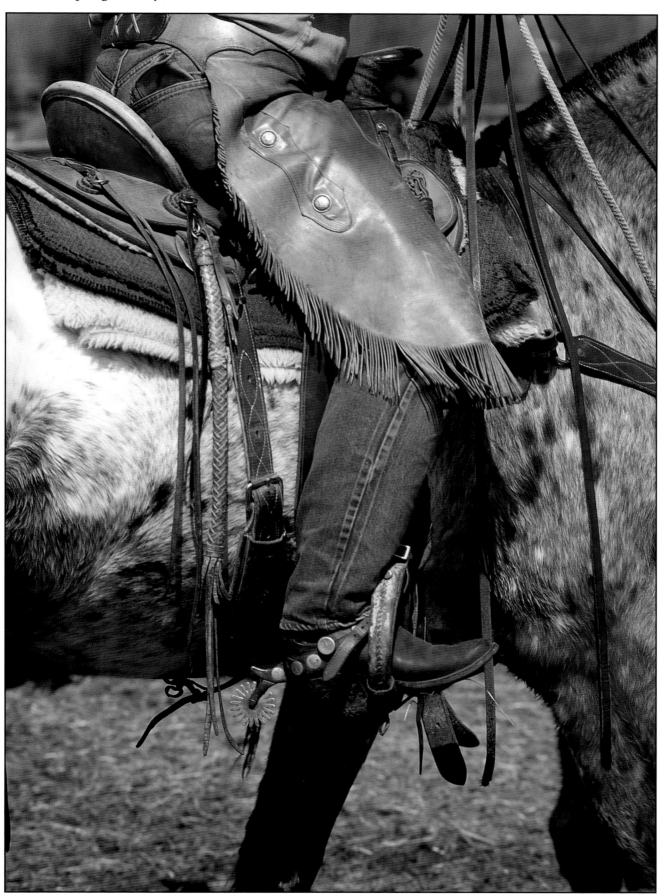

And lambs that match,

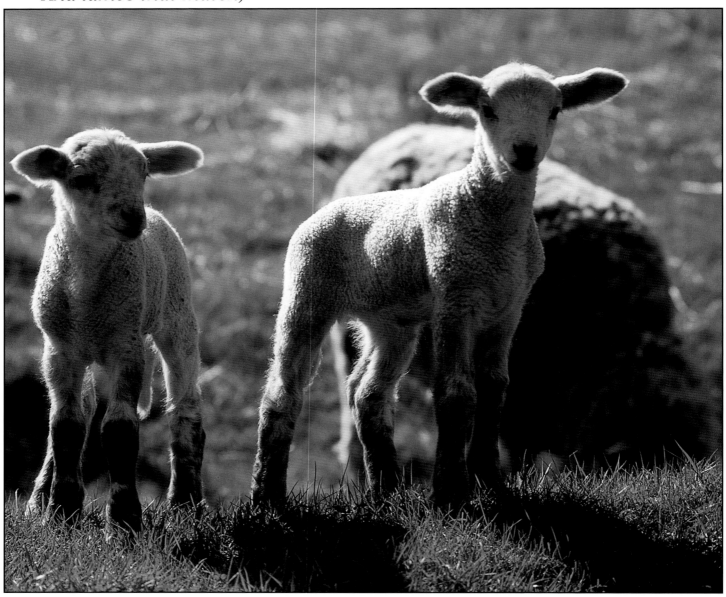

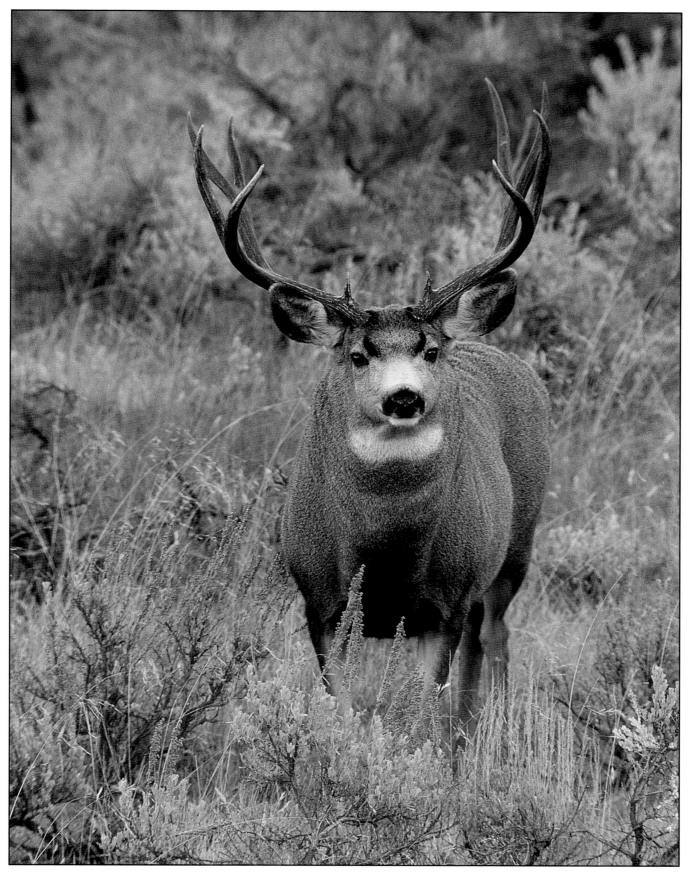

A muley in a sage brush patch.

It's waterin' up

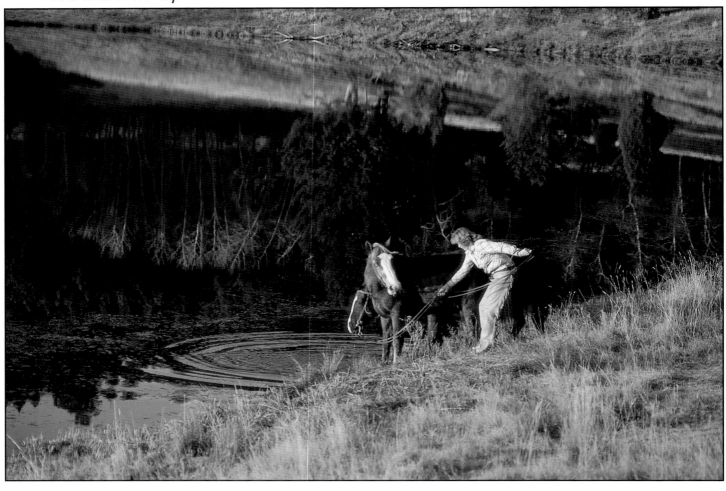

It's waterin' up
And pitchin' hay
And, in a tree, a bright eyed jay.
It's mornin's cold
And baby hawks
And salt all sculpted in a box.

And pitchin' hay

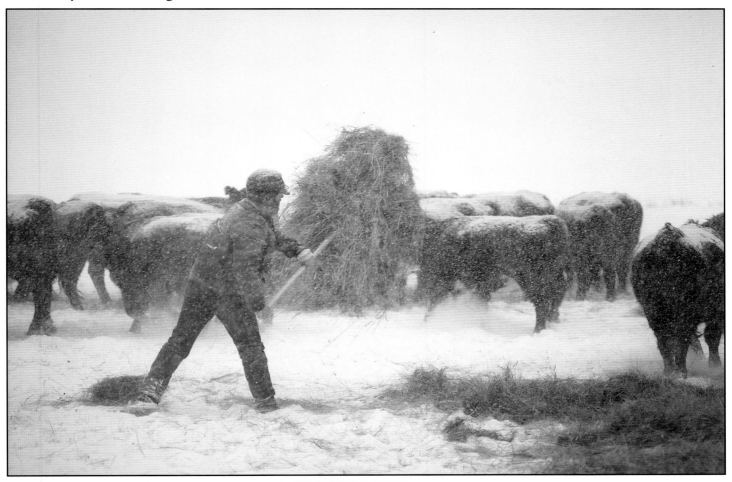

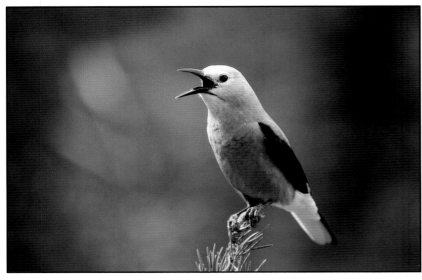

And, in a tree, a bright eyed jay.

It's mornin's cold

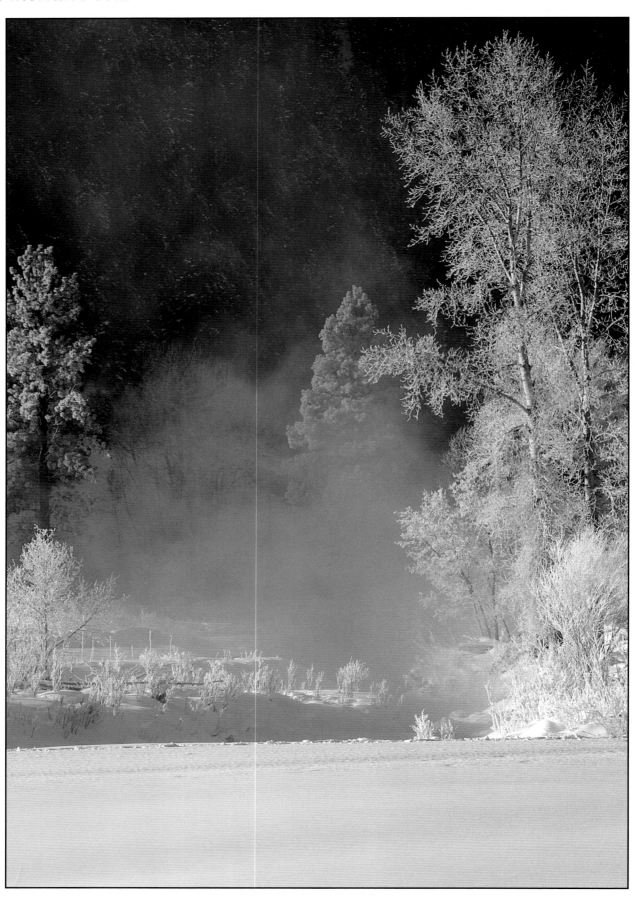

And baby hawks

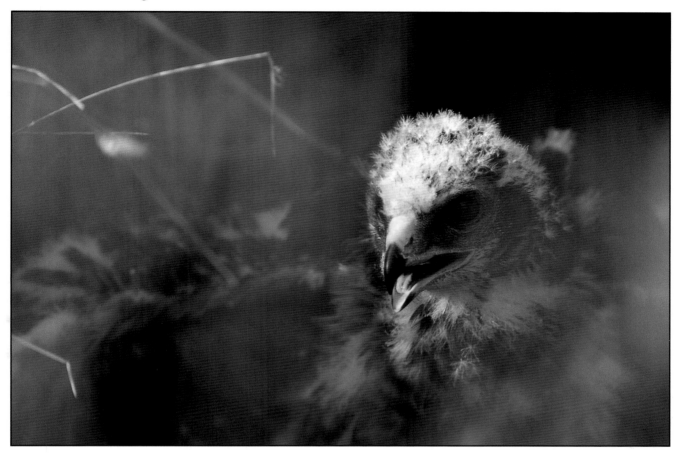

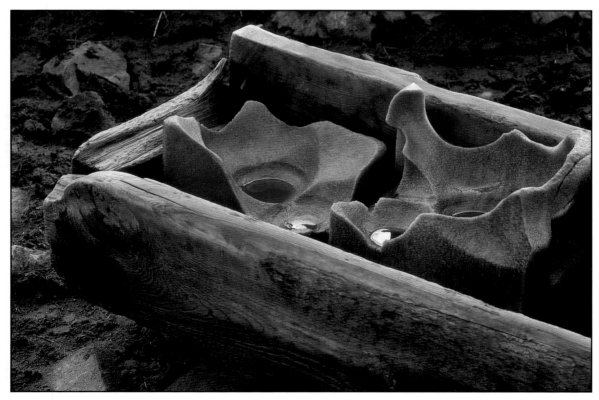

And salt all sculpted in a box.

It's leaves of gold

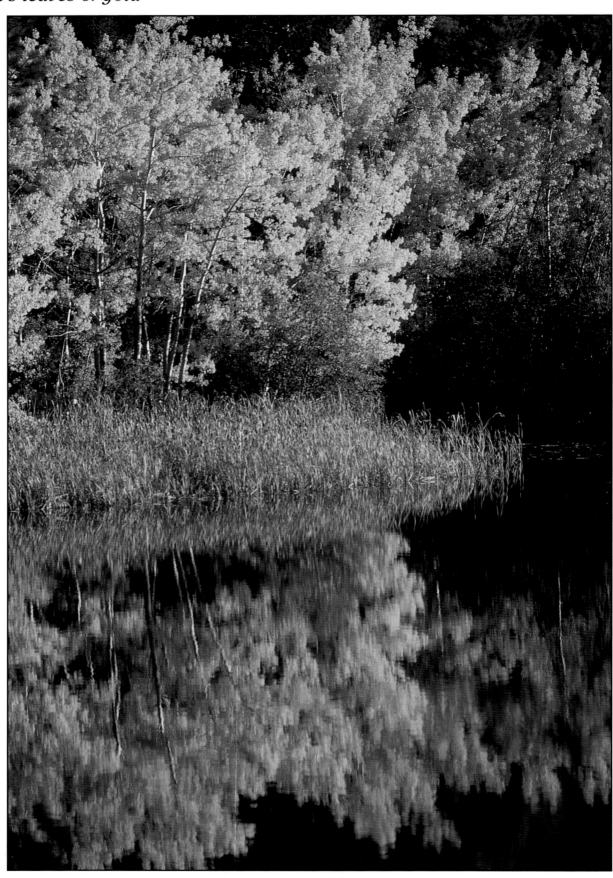

It's leaves of gold
And waters warm.
A puncher caught out in a storm.
It's big red bulls
And old time rakes
And lonely roads a rancher takes.

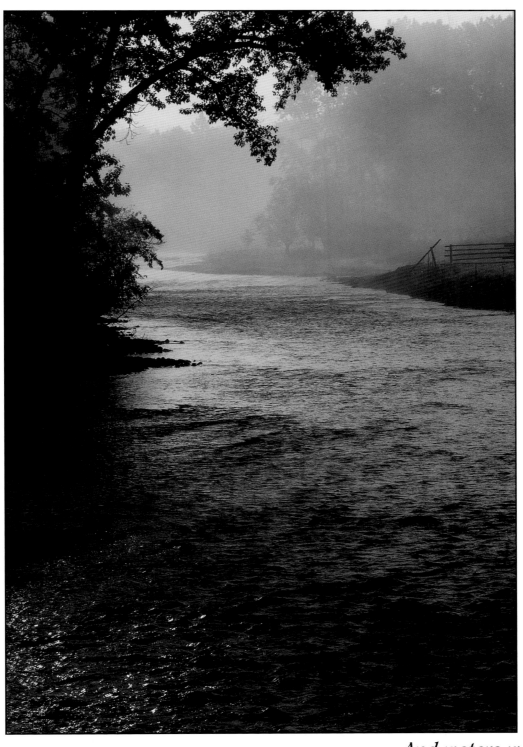

And waters warm.

A puncher caught out in a storm.

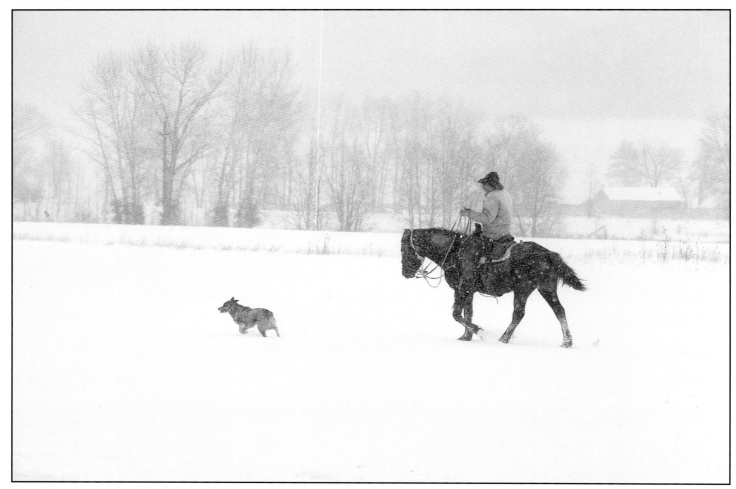

It's big red bulls

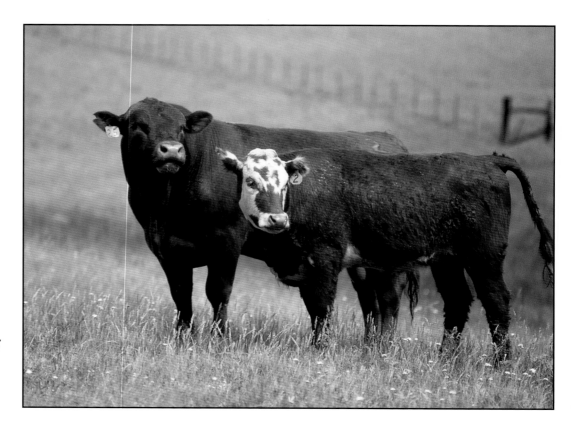

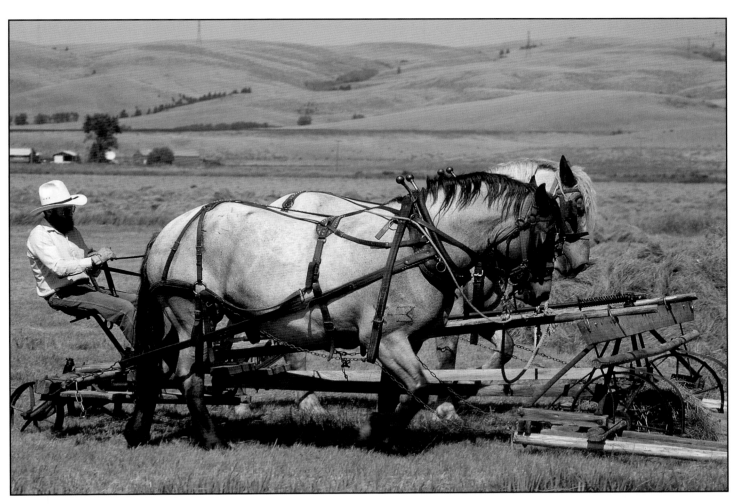

And old time rakes

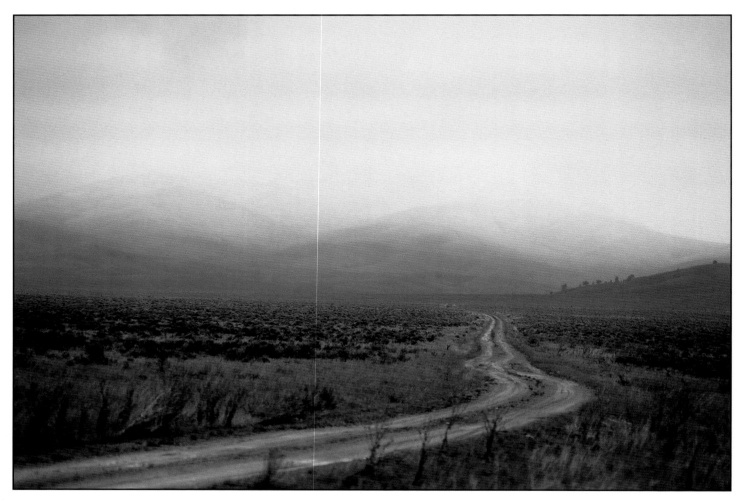

And lonely roads a rancher takes.

It's ridin' out
And larks that sing
And chasin' water in the spring.
It's pickup trucks
And wobblin' up
And, actin' tough, a heeler pup.

It's ridin' out

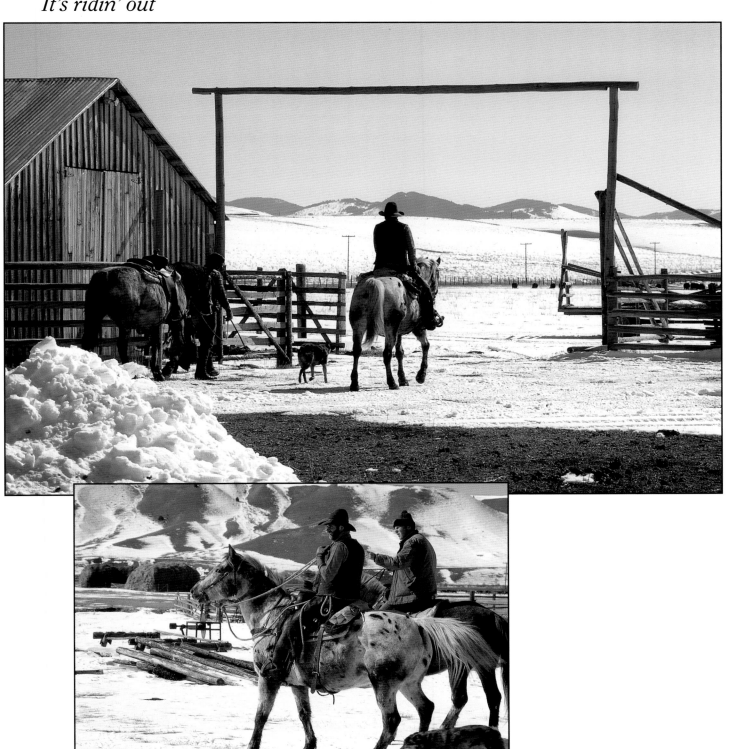

And larks that sing

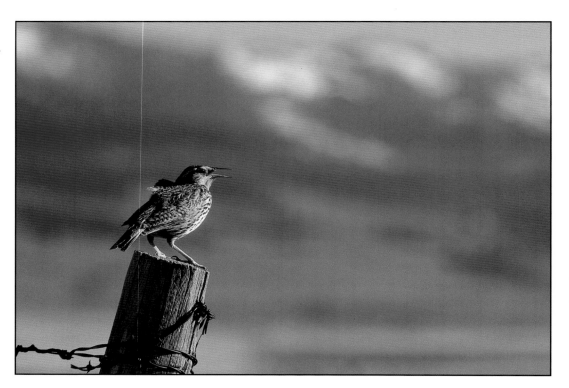

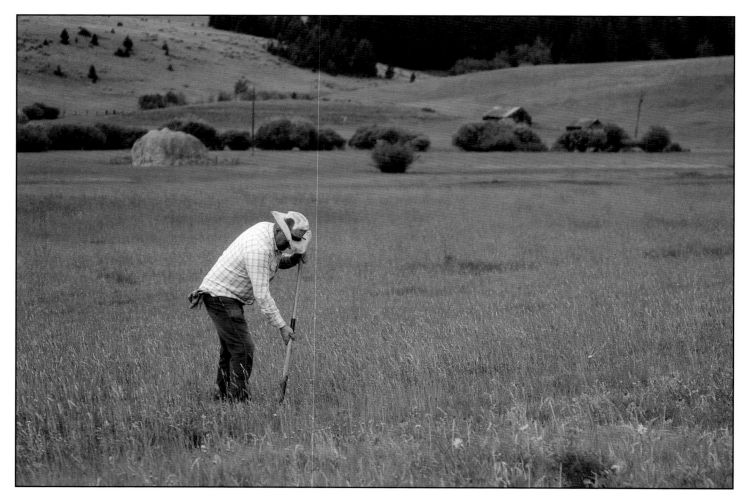

And chasin' water in the spring.

It's pickup trucks

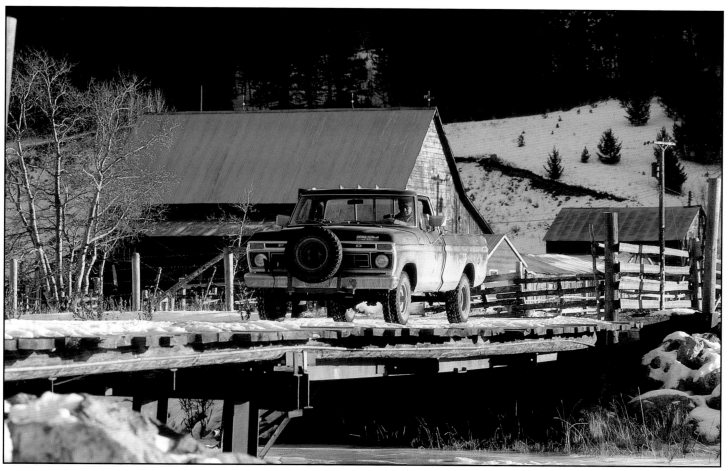

And wobblin' up

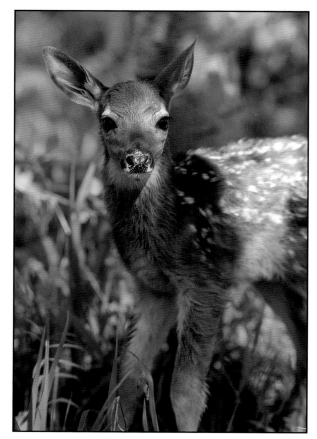

And, actin' tough, a heeler pup.

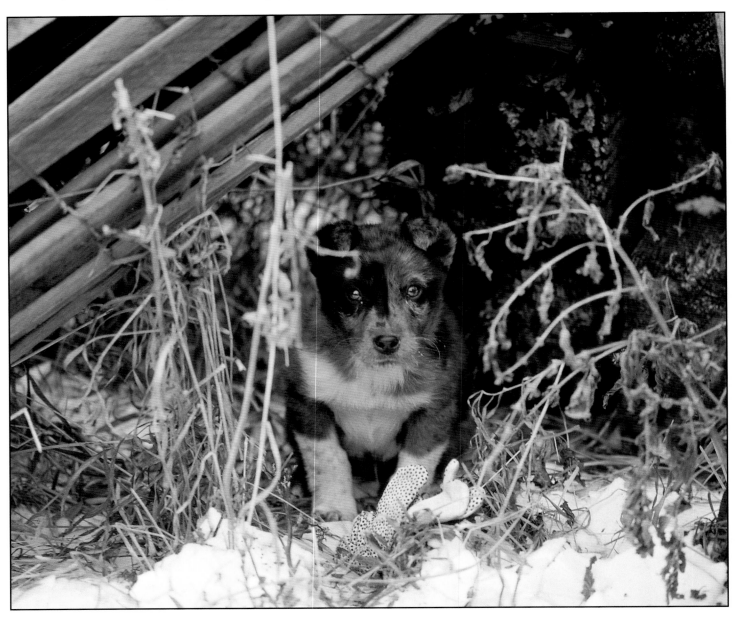

It's colt lunch breaks
A blizzard ride
And new arms on a beaverslide.
It's mother'n' up
And comin' home
And pastures where the coyotes roam.

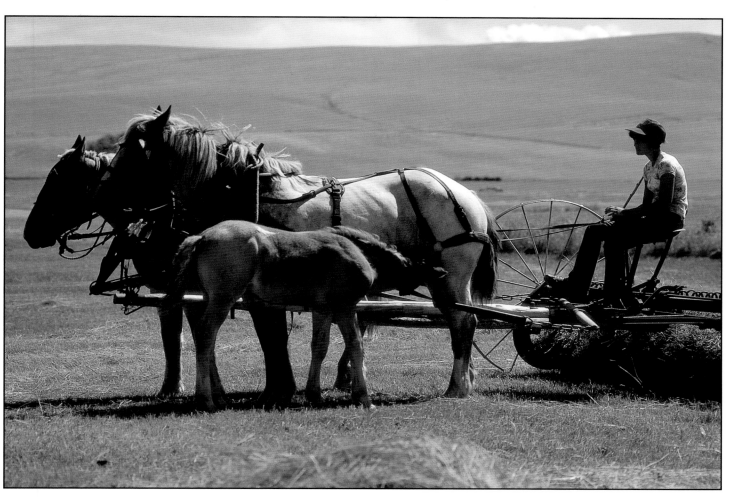

It's colt lunch breaks

A blizzard ride

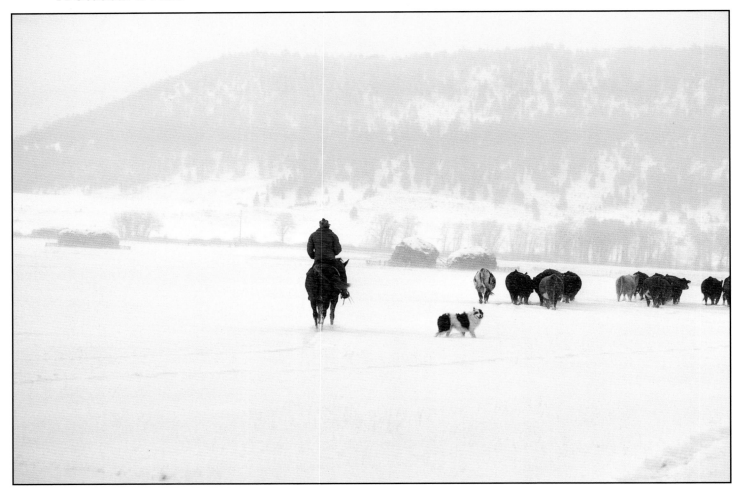

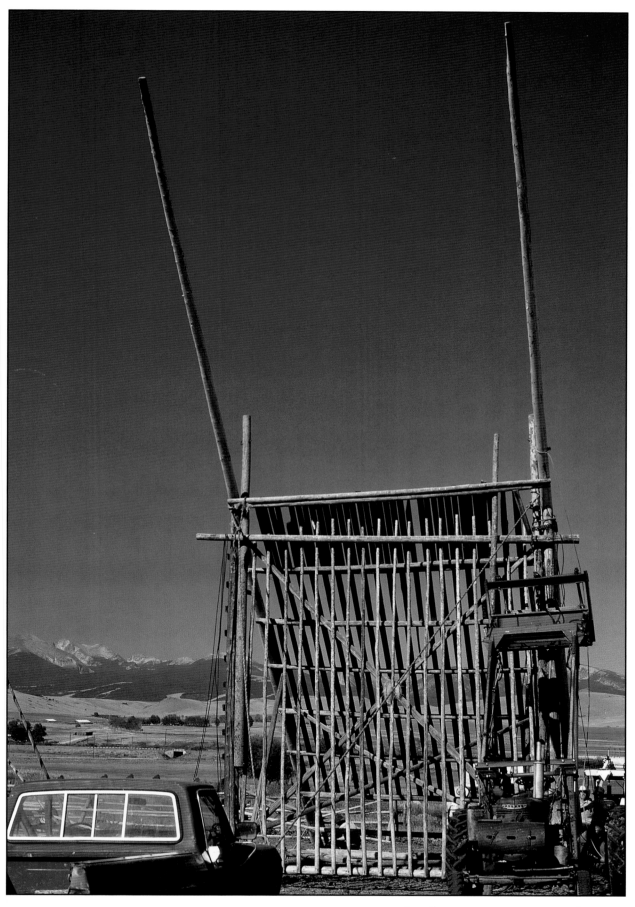

And new arms on a beaverslide.

It's mother'n' up

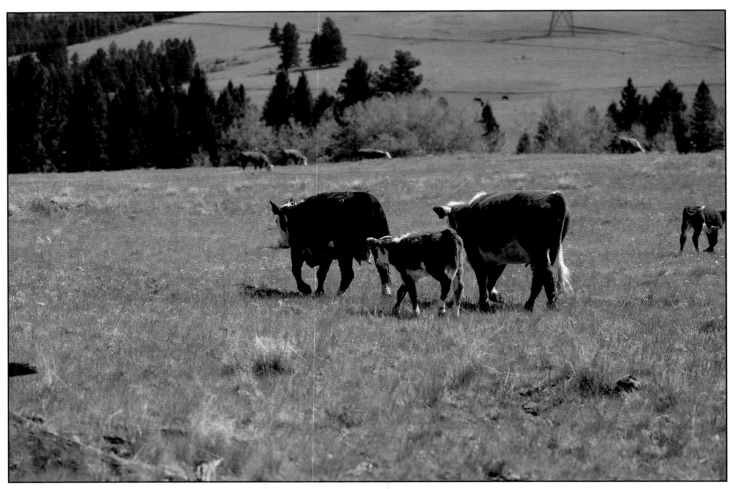

And comin' home

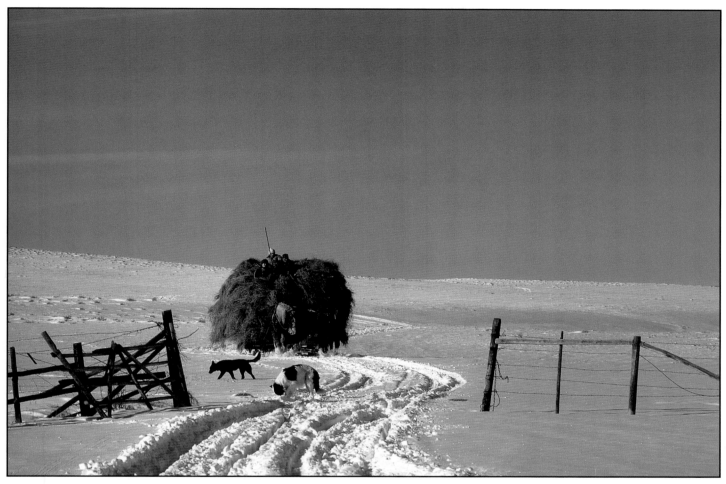

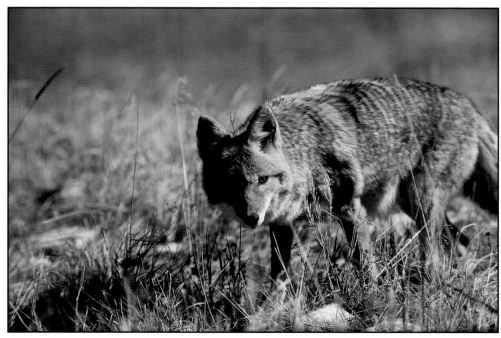

And pastures where the coyotes roam.

It's shippin' days

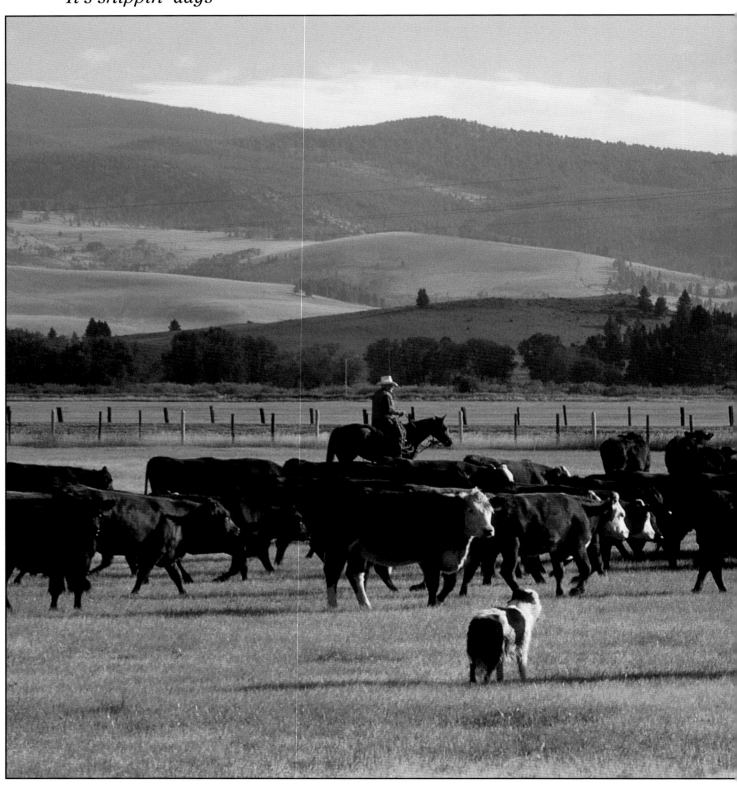

It's shippin' days
And hills to climb.
A hunter stopped to pass the time.
It's hitchin' up
A high pole gate
A ruff grouse drummin' for a mate.

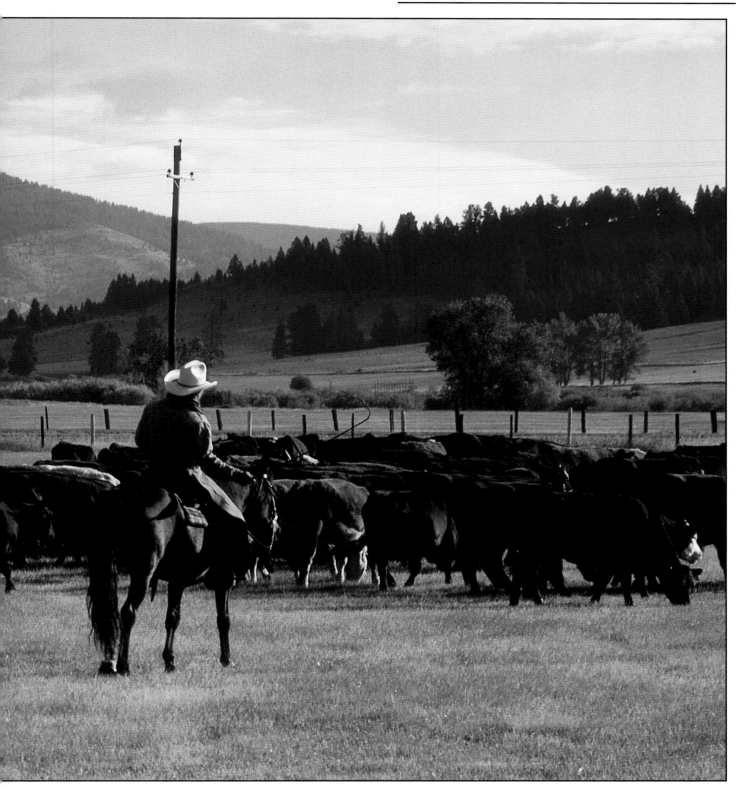

And hills to climb.

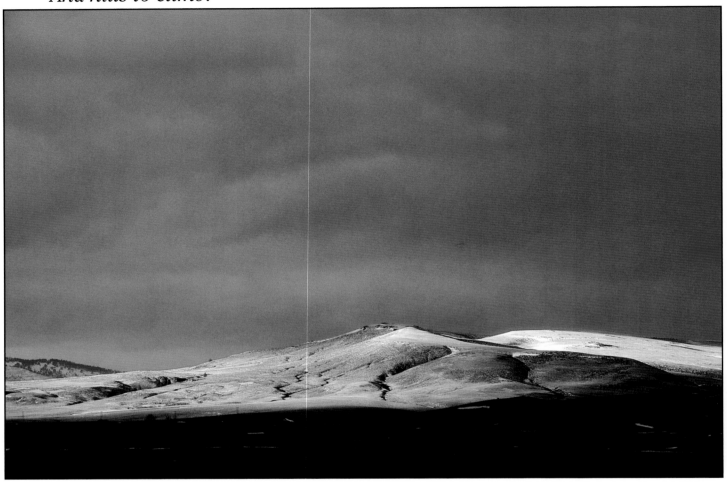

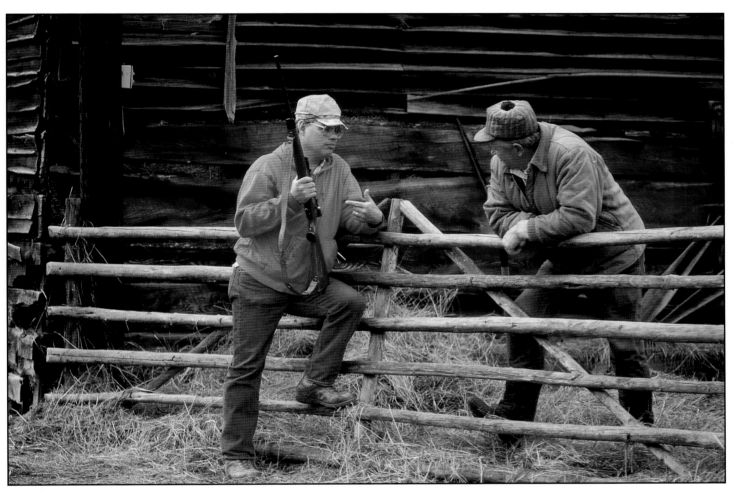

A hunter stopped to pass the time.

It's hitchin' up

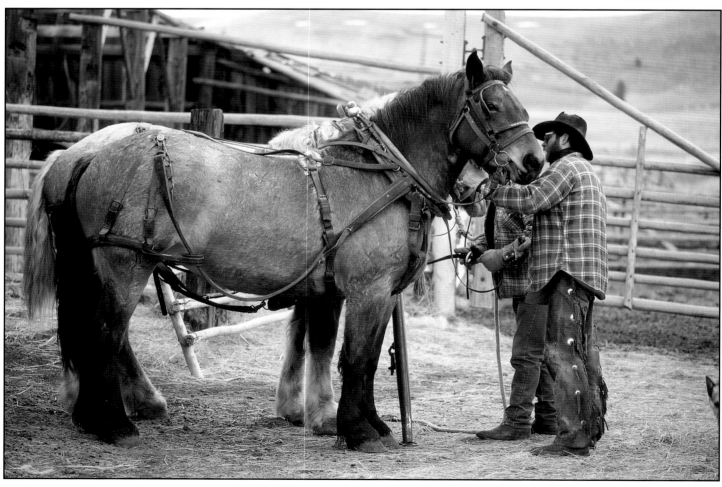

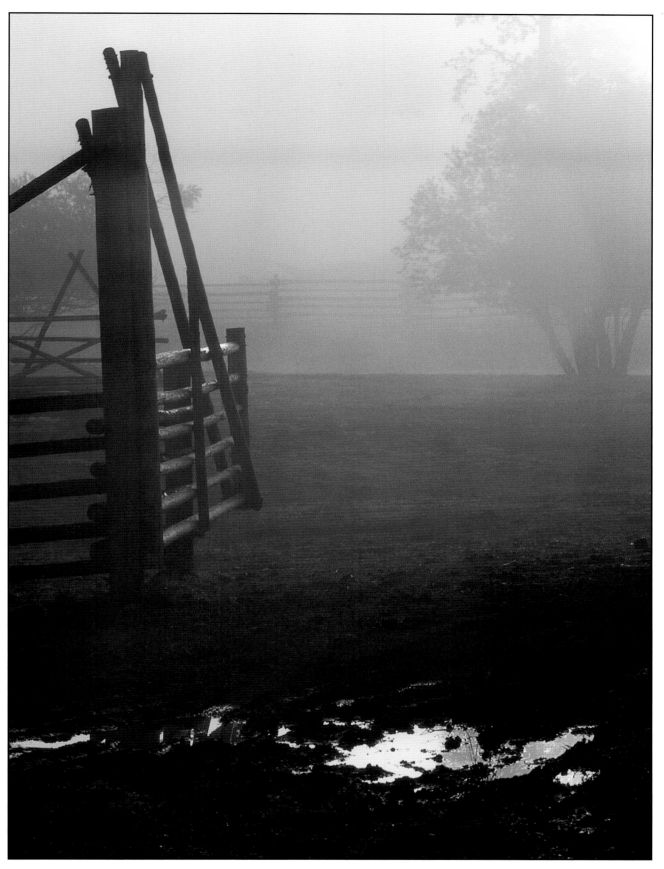

A high pole gate

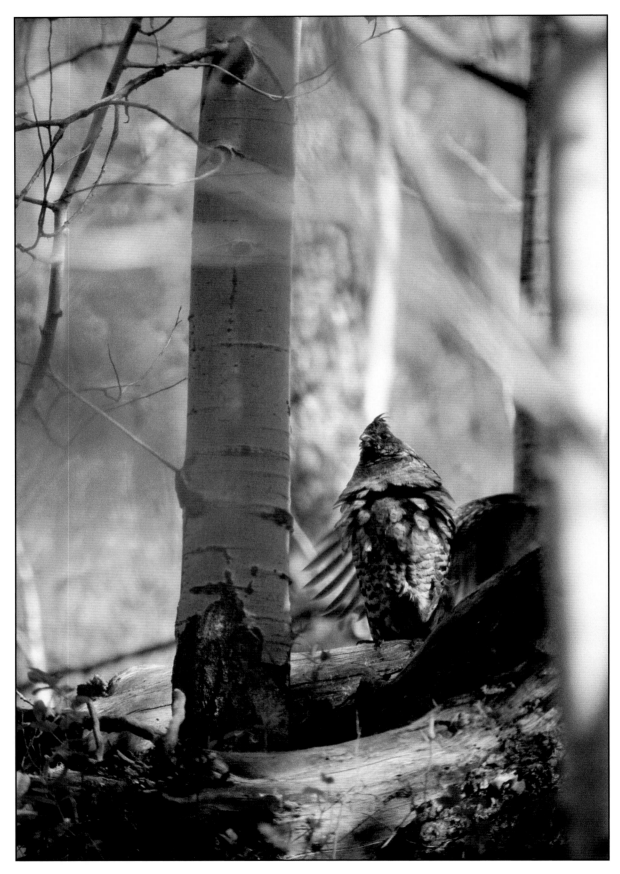

A ruff grouse drummin' for a mate.

It's heelin' calves
And settin' brands
And cuttin' knives in practiced hands.
It's weathered barns
A saddle bag
And, on a drive, it's ridin' drag.

It's heelin' calves

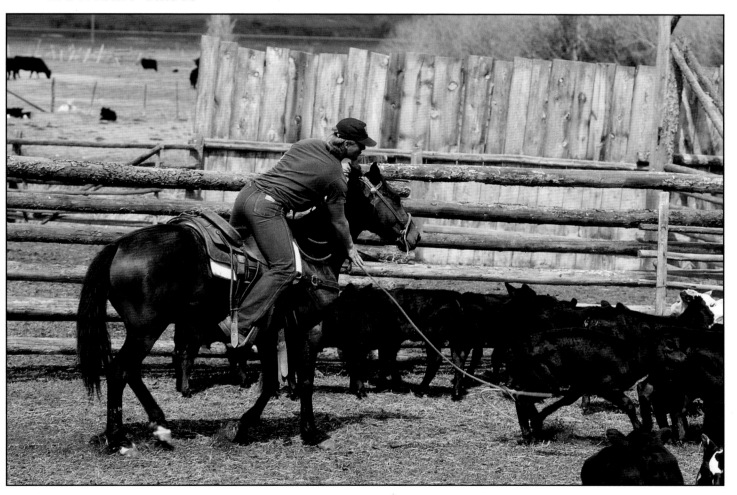

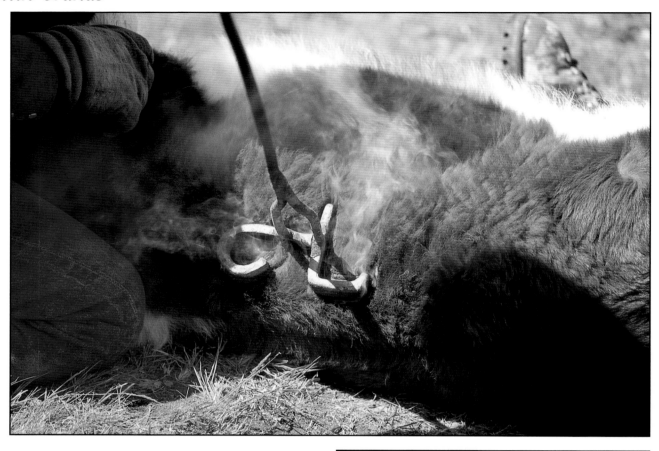

And cuttin' knives in practiced hands.

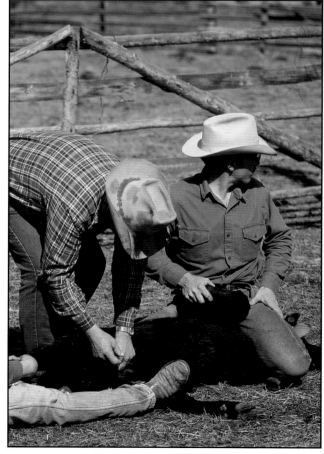

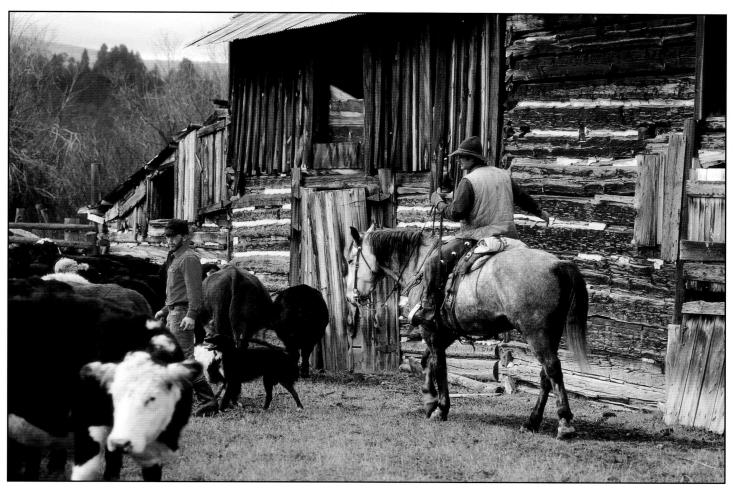

It's weathered barns

A saddle bag

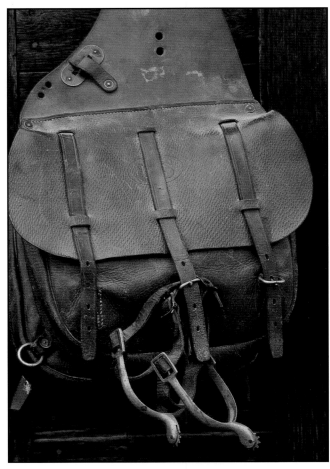

And, on a drive, it's ridin' drag.

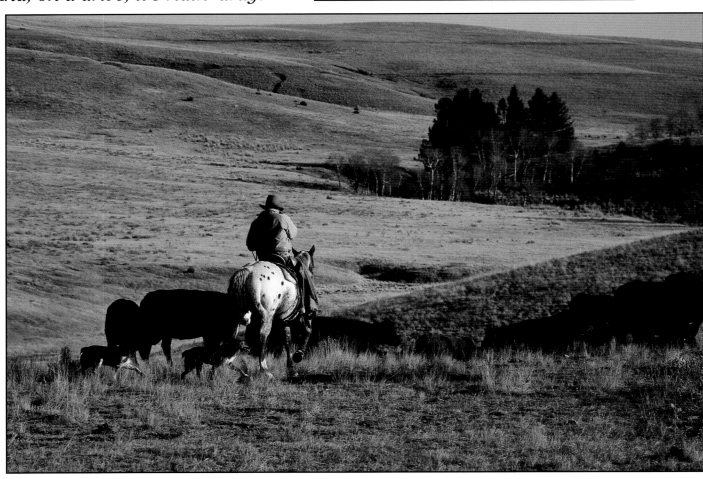

It's monuments
And buildin' stacks
And drivin' in a team of blacks.
It's buglin' bulls
A rainy day.
A red fox mousin' new cut hay.

It's monuments

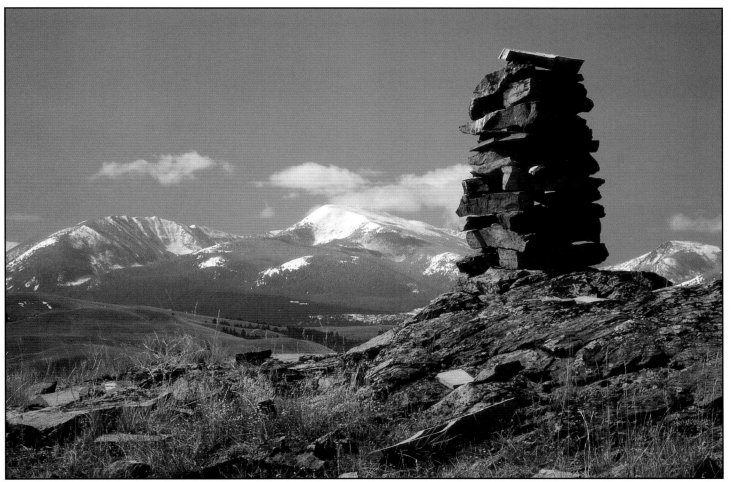

And buildin' stacks

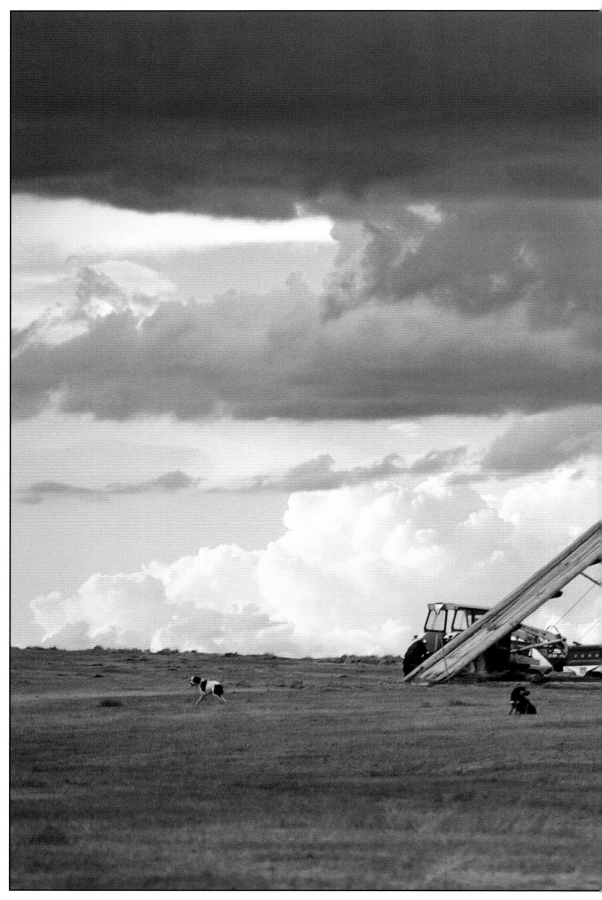

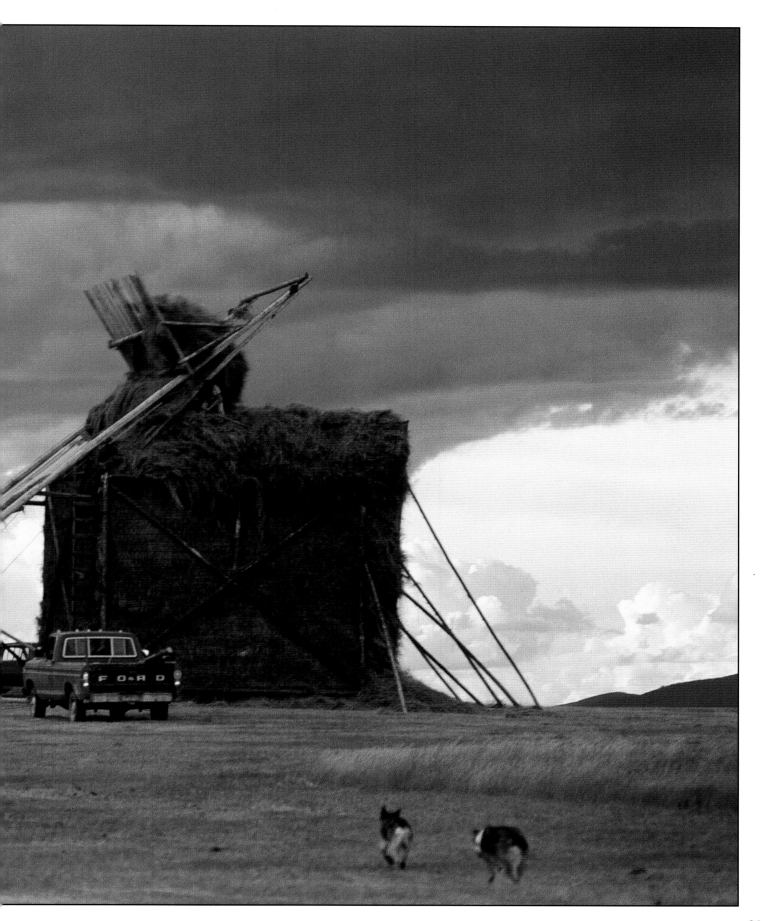

And drivin' in a team of blacks.

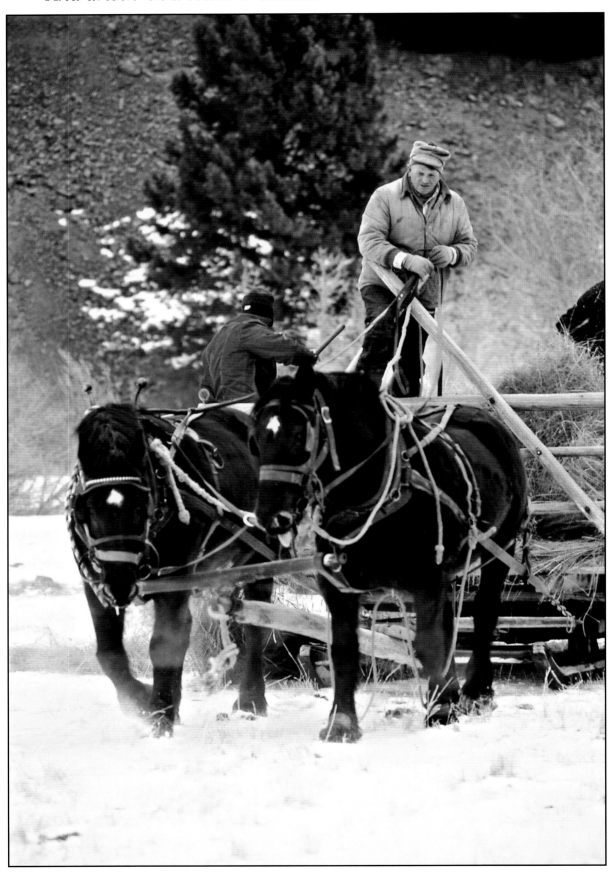

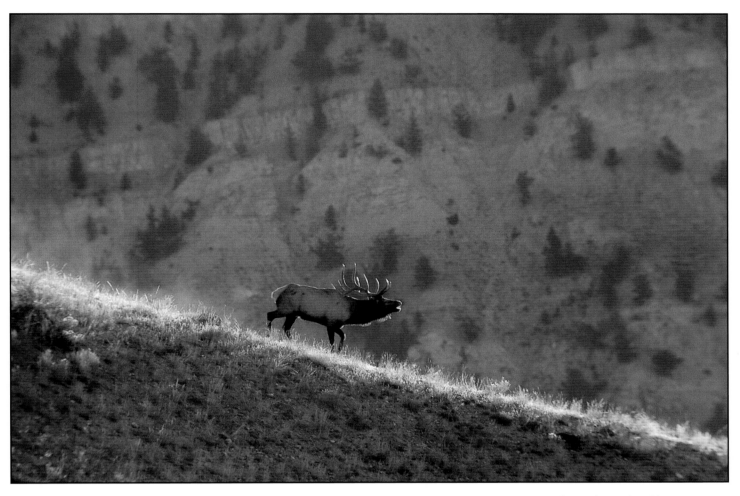

It's buglin' bulls

A rainy day.

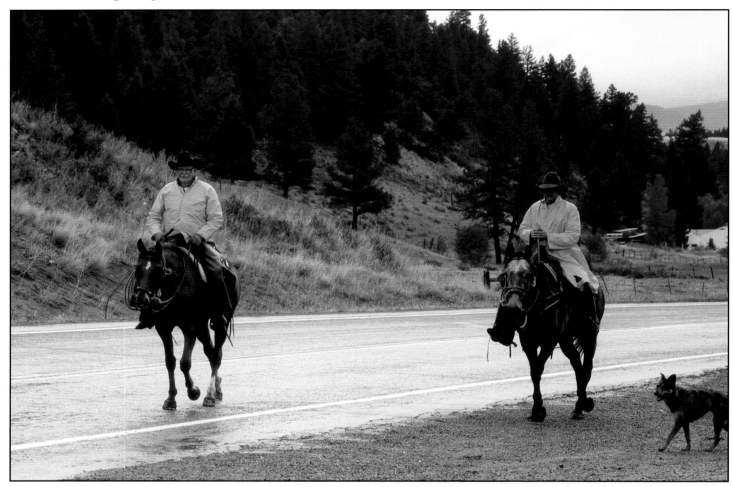

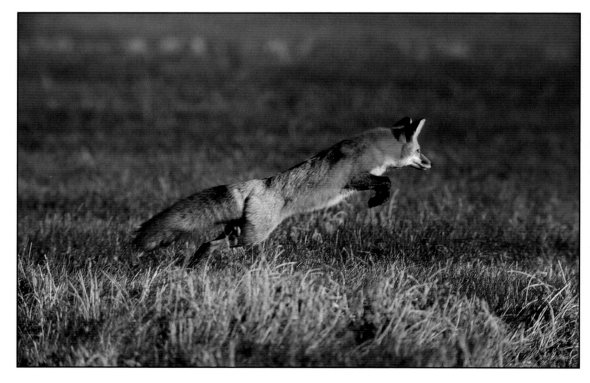

A red fox mousin' new cut hay.

It's flowers wild
Sleigh bells of brass
And springtime with its new green grass.
It's ropin' ropes
And shotgun chaps
And, in the cold, it's winter caps.

It's flowers wild

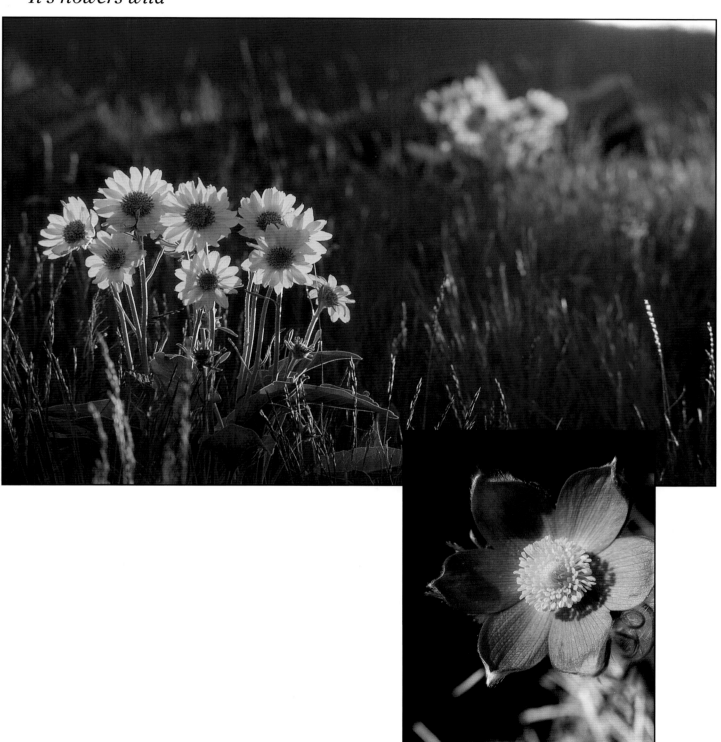

Sleigh bells of brass

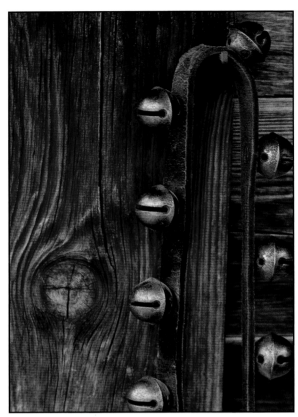

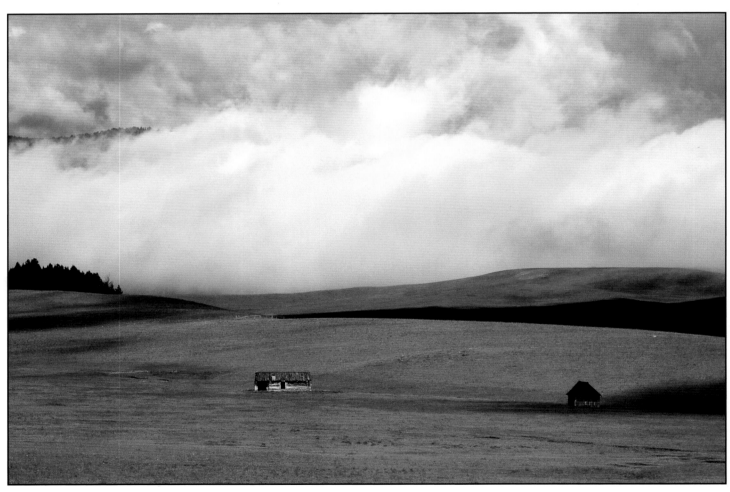

And springtime with its new green grass.

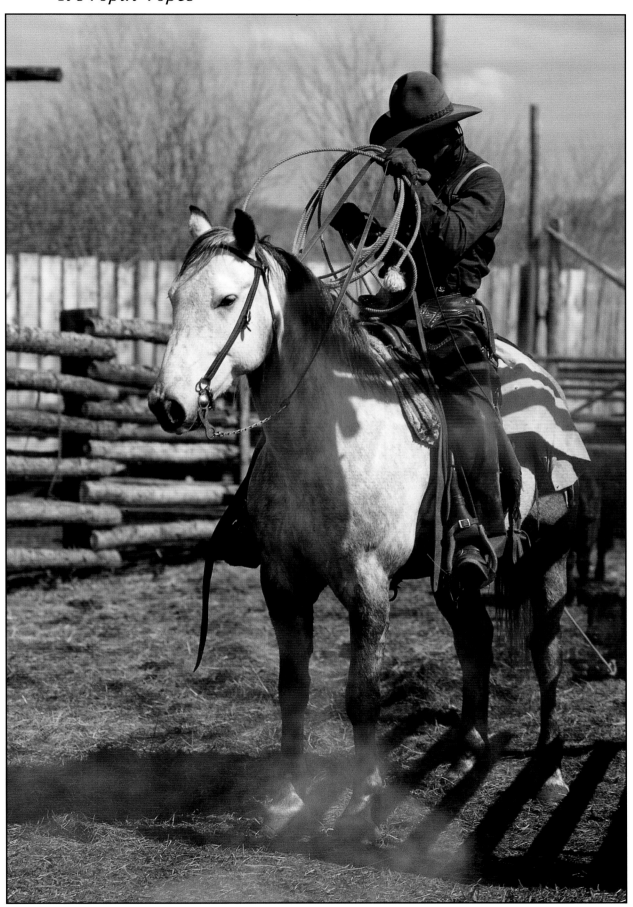

And shotgun chaps

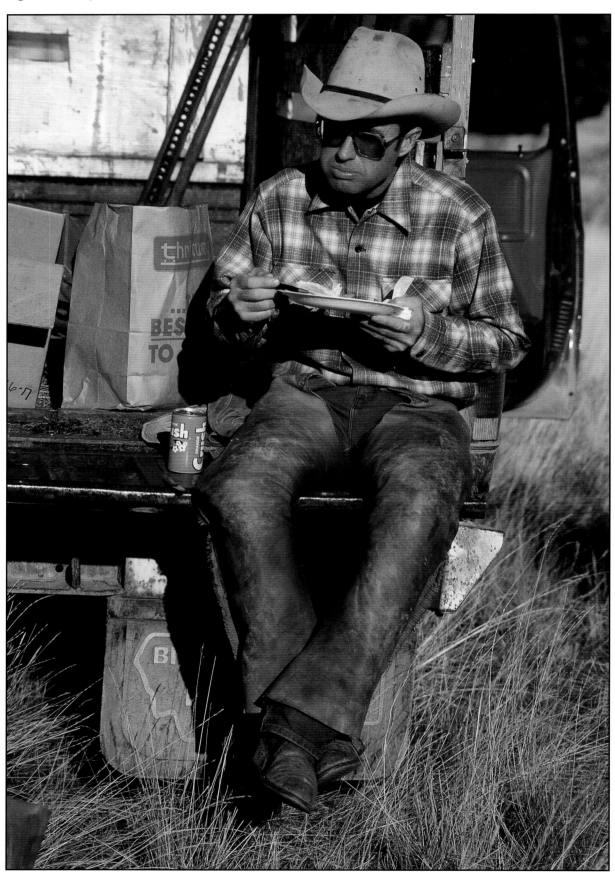

And, in the cold, it's winter caps.

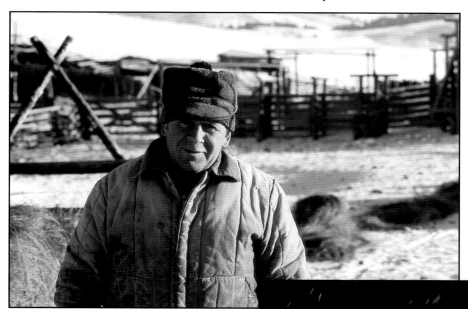

It's jackrabbits

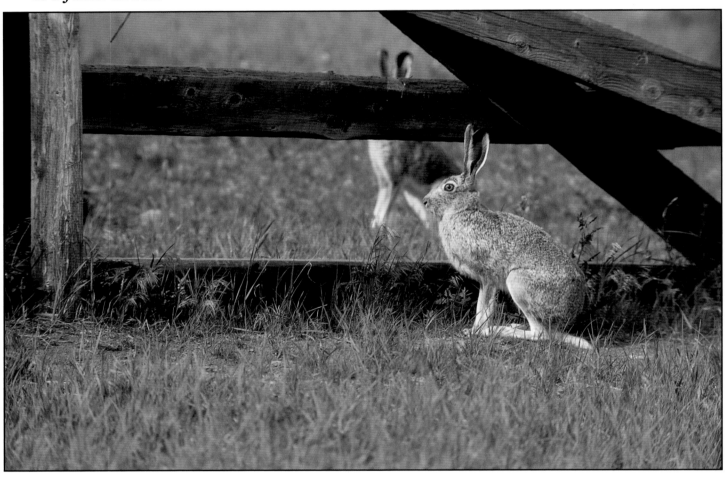

It's jackrabbits
A final load
Across a bridge a snowy road.
It's calvin' time
Full moons at night
And valleys shinin' rainbow bright.

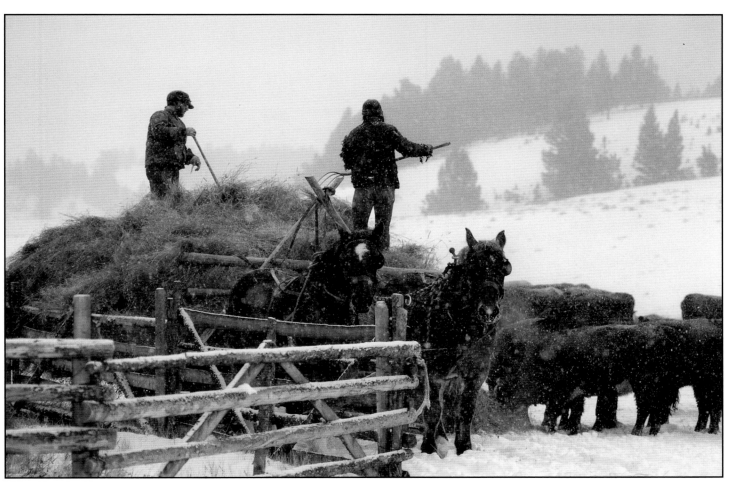

A final load

Across a bridge a snowy road.

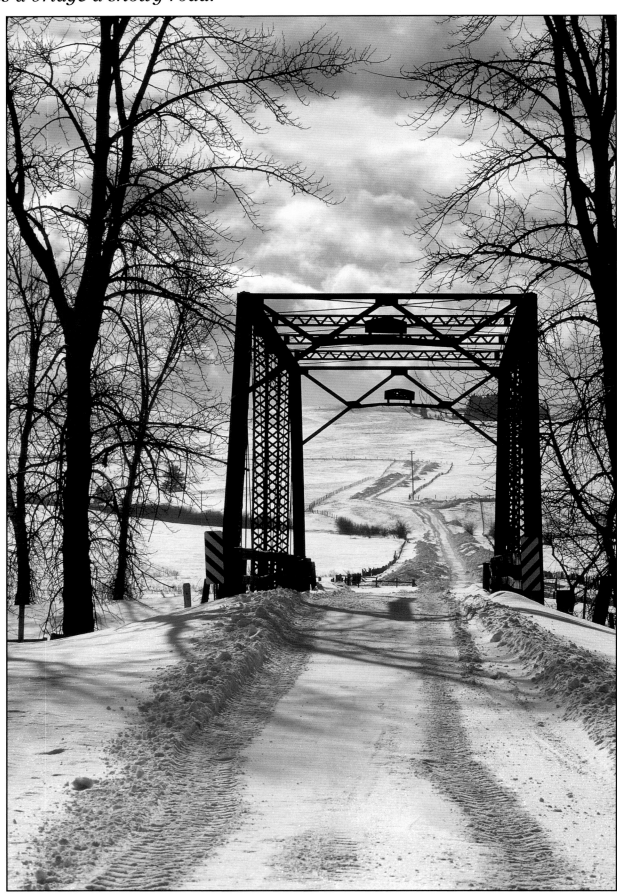

It's calvin' time

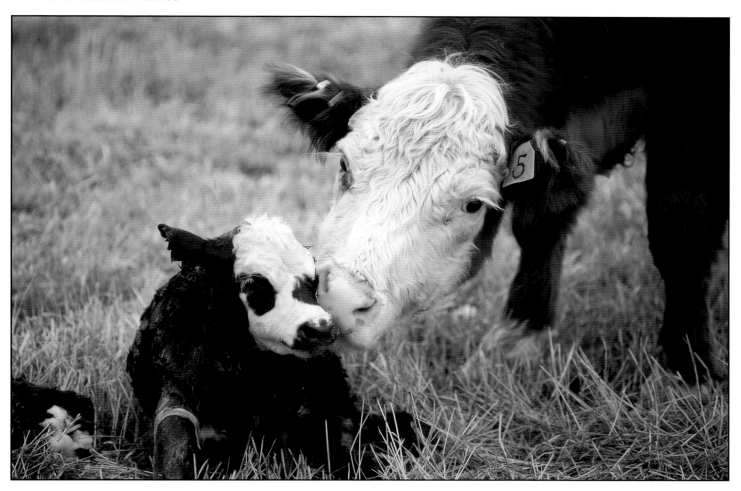

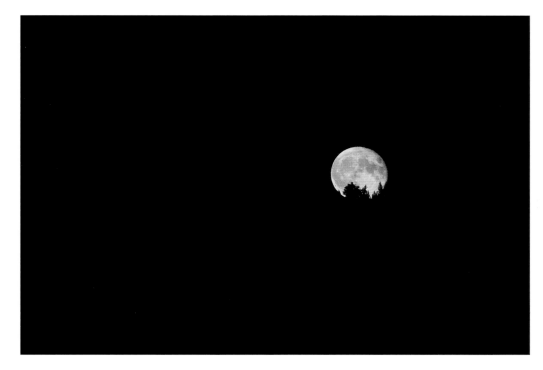

Full moons at night

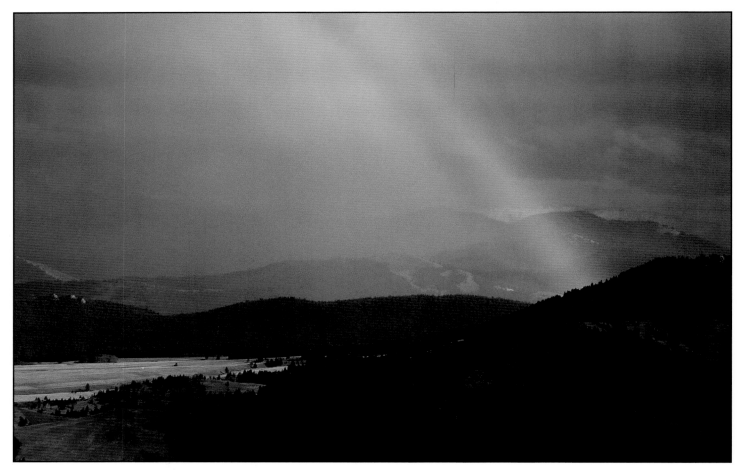

And valleys shinin' rainbow bright.

It's power lines
And tiny towns
And palominos, bays and browns.
It's weanin' calves
And changin' flats
And, in the sun, contented cats.

It's power lines

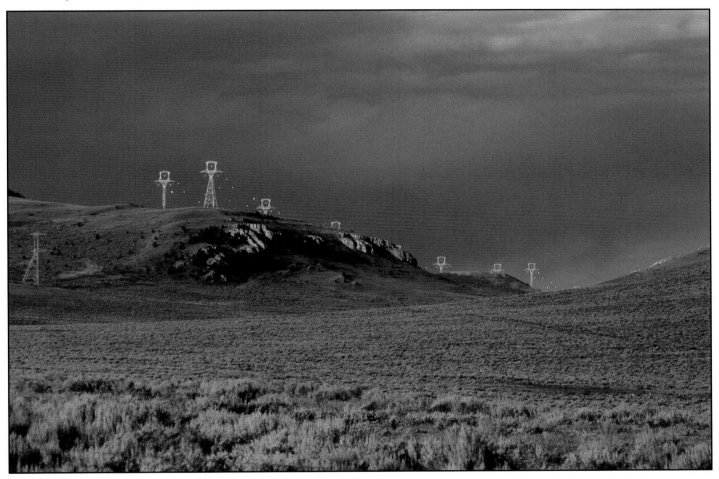

And tiny towns

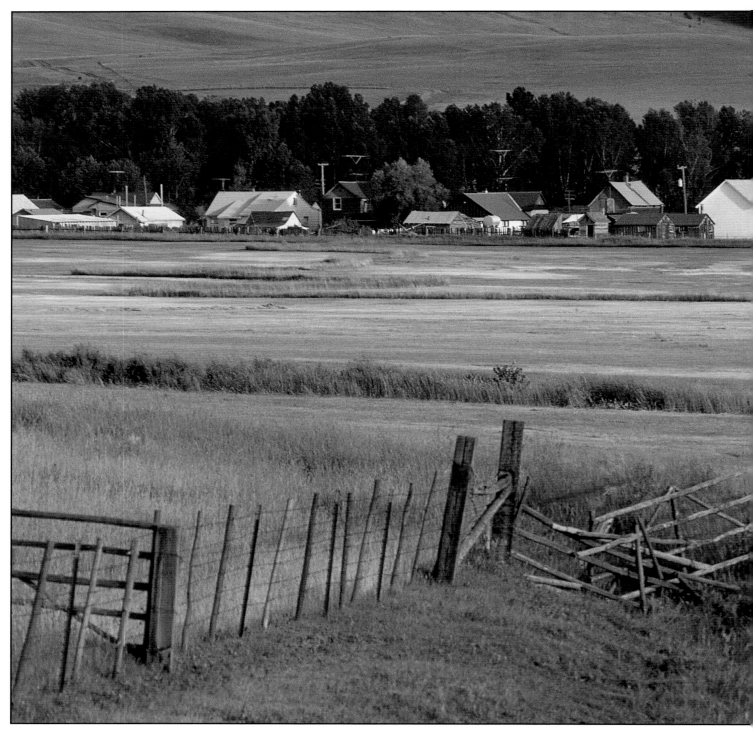

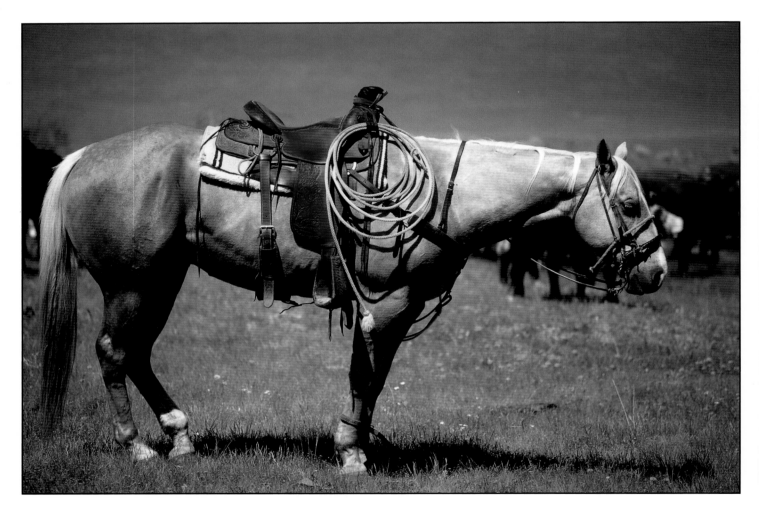

And palominos, bays and browns.

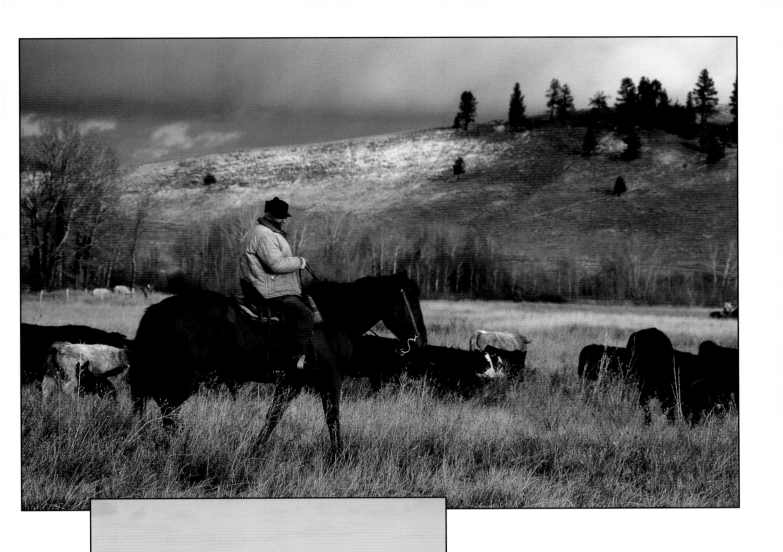

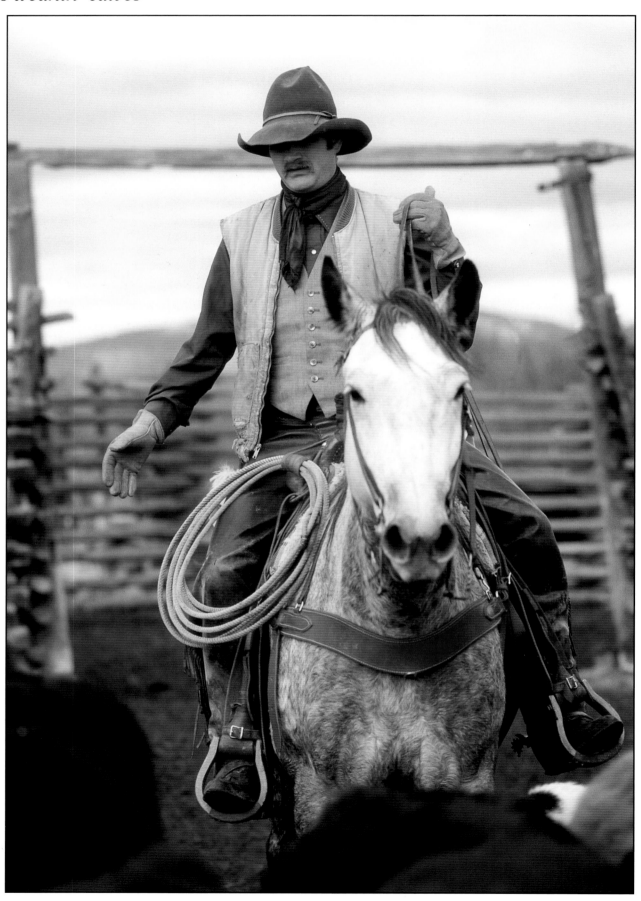

And changin' flats

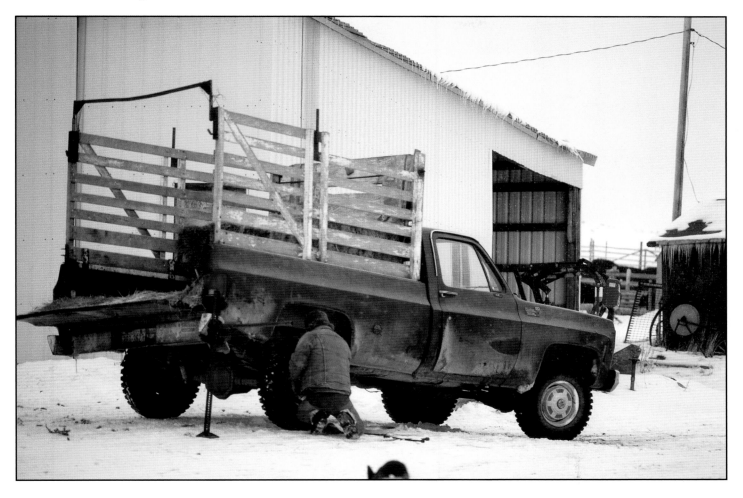

And, in the sun, contented cats.

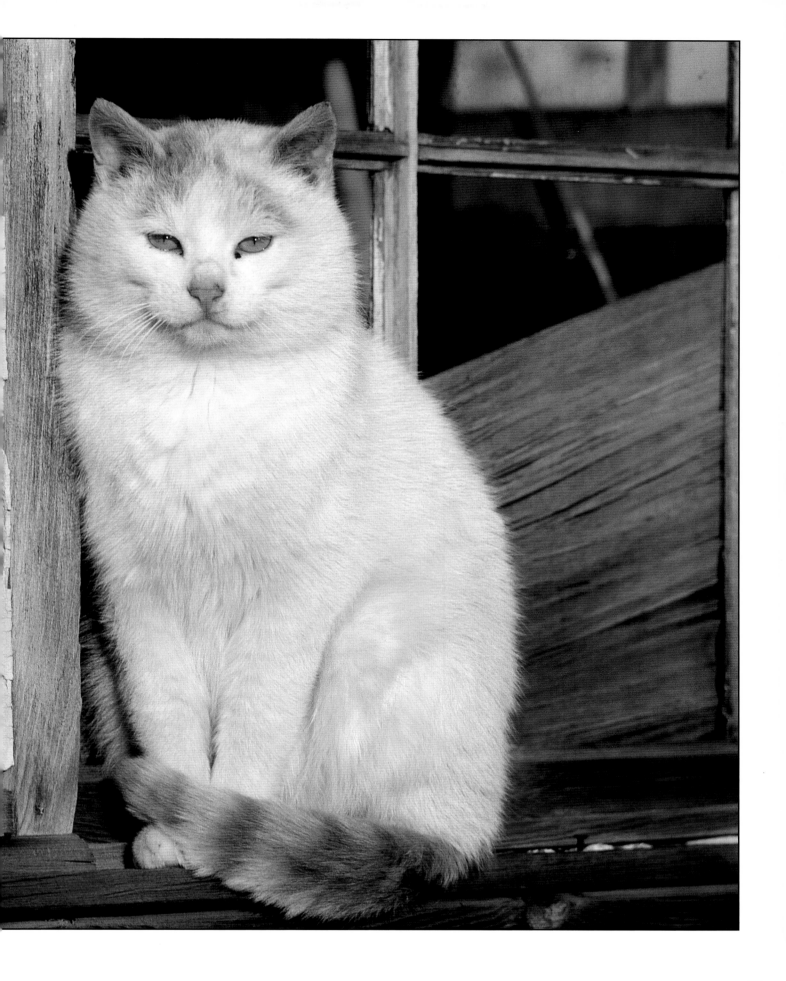

It's passin' storms

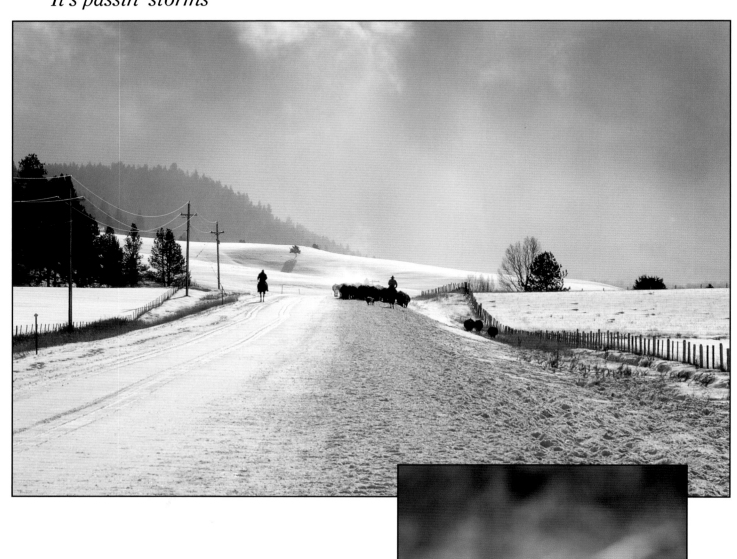

And fool grouse hens

It's passin' storms
And fool grouse hens
And workin' cows in shippin' pens.
It's smokes to build
And makin' tracks
And panels 'round high mounded stacks.

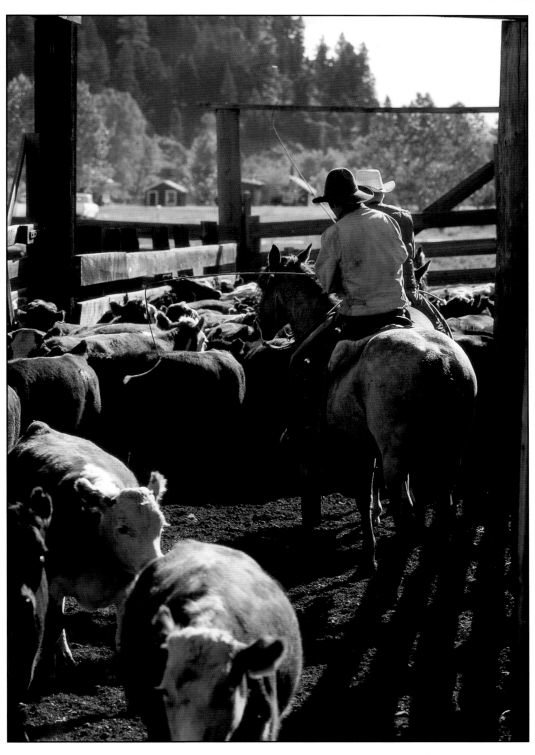

And workin' cows in shippin' pens.

It's smokes to build

And makin' tracks

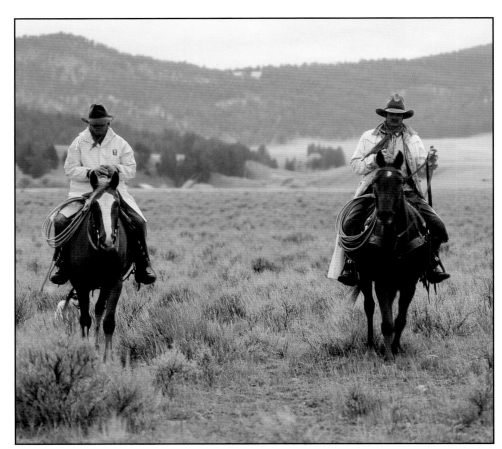

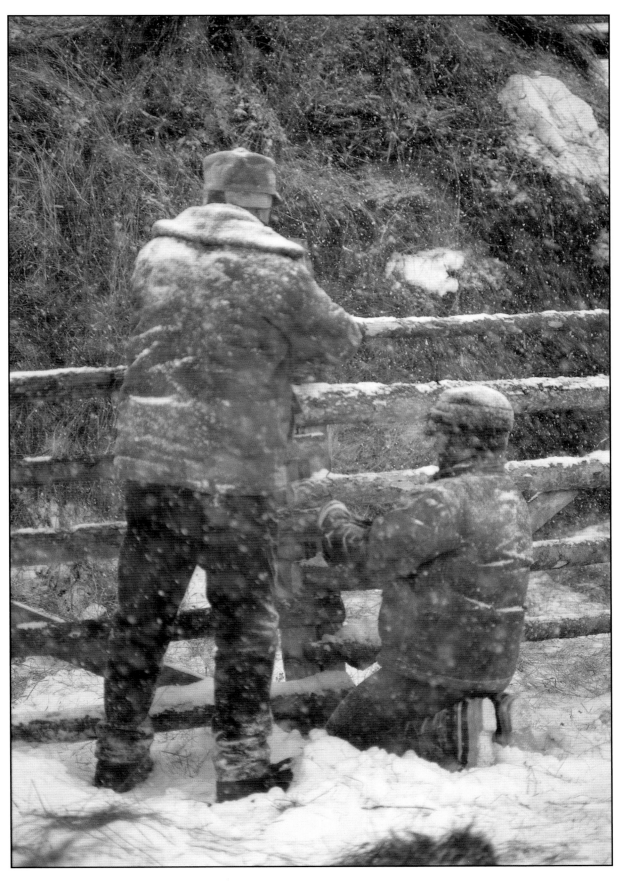

And panels 'round high mounded stacks.

It's mud and snow

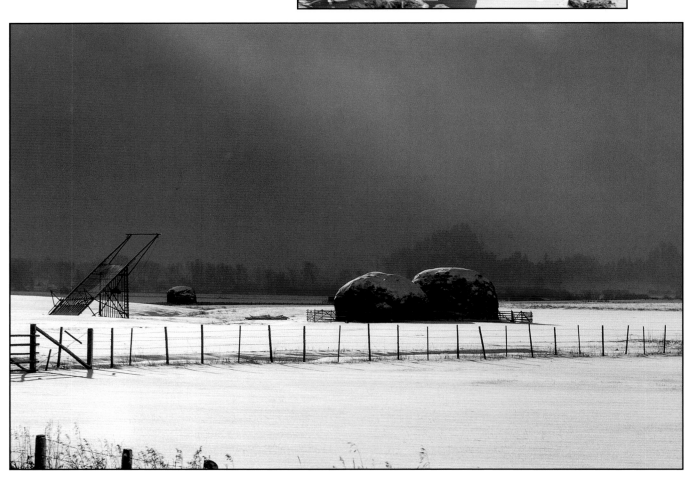

It's mud and snow
And bitter cold
A Belgian burnished copper gold.
It's ranchers' sons
And ranchers' wives
And bears that raid the honeyed hives.

And bitter cold

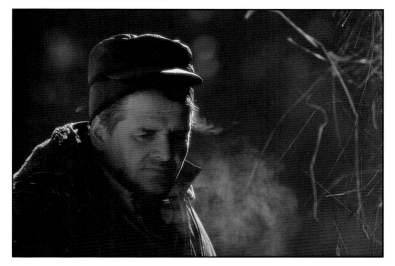

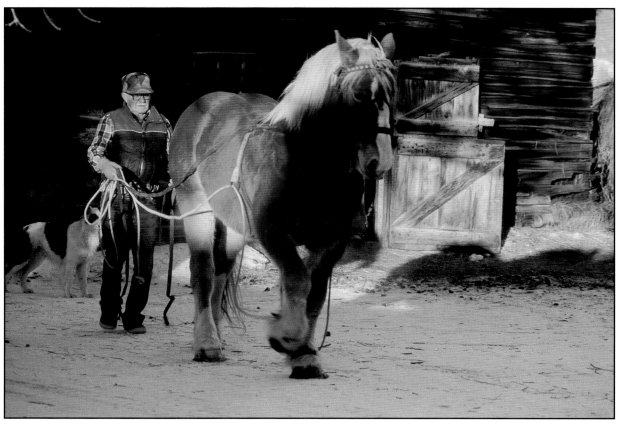

A Belgian burnished copper gold.

It's ranchers' sons

And ranchers' wives

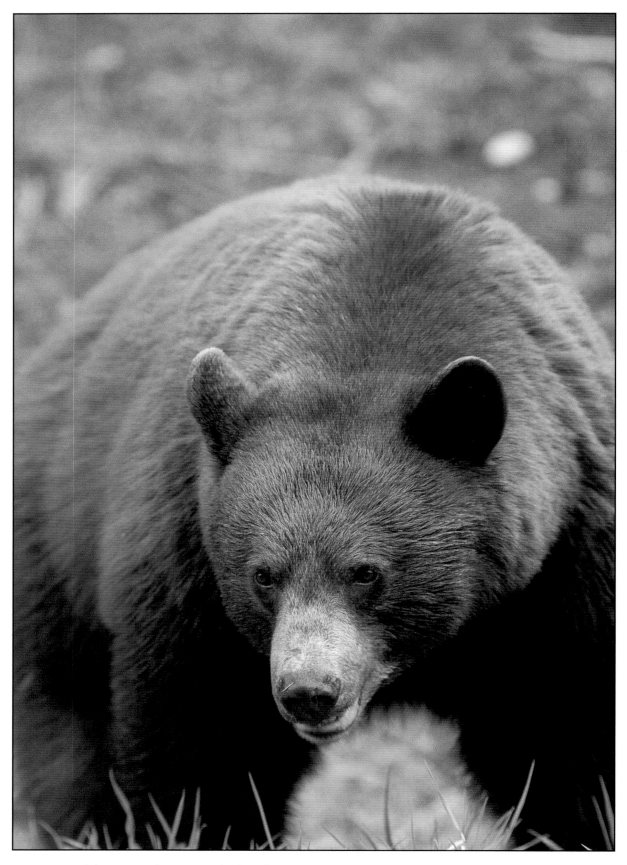

And bears that raid the honeyed hives.

It's miles to ride
And work horse teams
And heifers crossin' snow fed streams.
It's gatherin'
A foggy morn
And strugglin' up a calf just born.

It's miles to ride

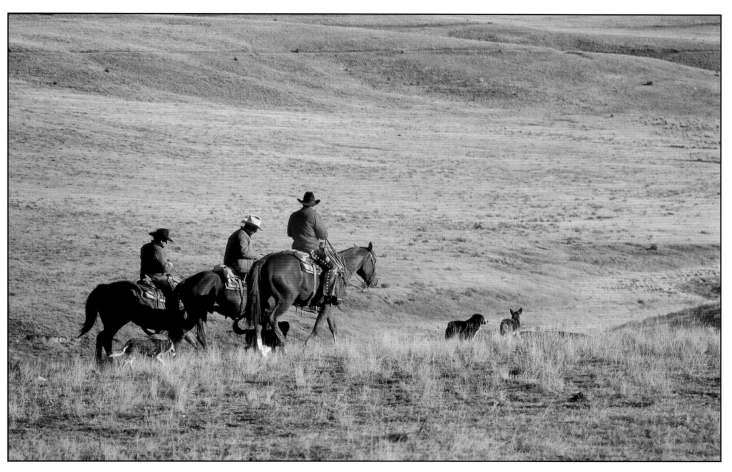

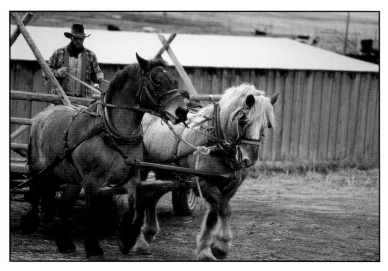

And work horse teams

93

And heifers crossin' snow fed streams.

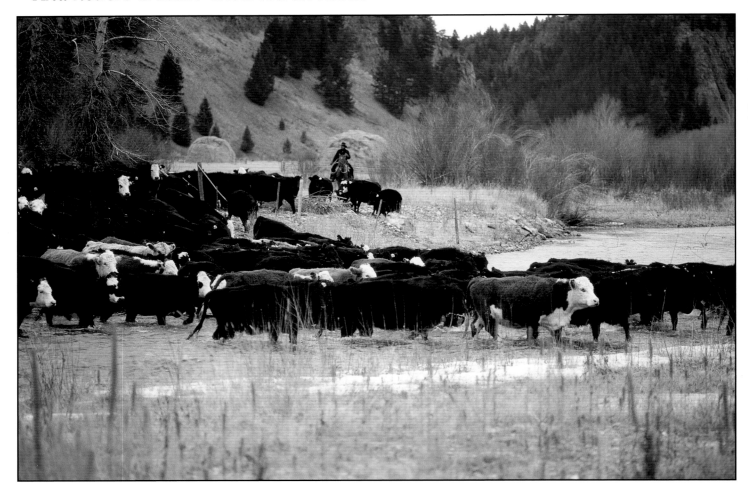

It's gatherin'

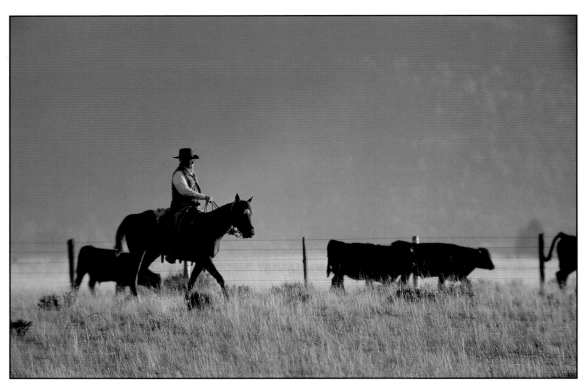

A foggy morn

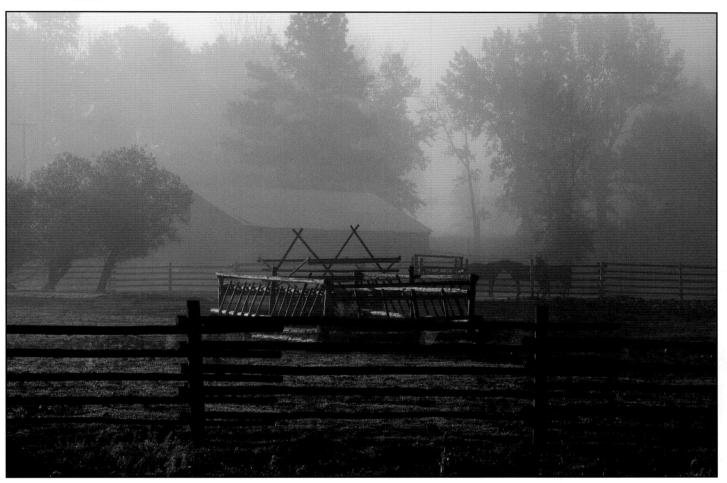

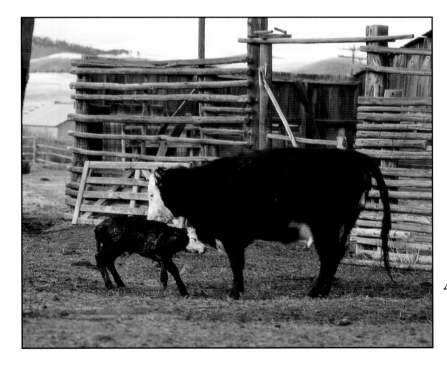

And strugglin' up a calf just born.

Ranchin' Is...

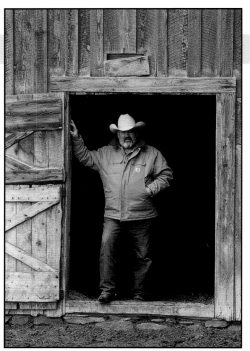

PHOTO BY SEAN LOGAN

About the Author

Photographer/cowboy poet Mike Logan's lifelong interest in ranch life has spurred him to capture his observations on film and in verse. Mike's insight and love of Montana and the West have won him national acclaim. He has been a featured poet and emcee at the Cowboy Poetry Gathering in Elko, Nevada and other gatherings throughout the United States and Canada. He was a guest on John Denver's "Montana Christmas Skies" television special. Mike's book and video *Montana Is. . .* was chosen to represent Montana in the Library of Congress Bicentennial Celebration in May 2000. His words and photographs have also been published in numerous books, magazines and calendars.

Buglin' Bull Press

Yellowstone Is…

Yellowstone National Park in exuberant verse and full-color photography.
96 pp., 8 1/2" x 11", 140 color photos, $13.95 softcover

Yellowstone Is…Video

A sweeping celebration of the world's first national park in verse and photography.
33 minutes, VHS, $15.95

Montana Is…

An exploration of Montana in verse and photography.
96 pp., 129 color photos. $13.95 softcover

Montana Is…Video

This video is a roundup of Mike Logan's visual impressions of Big Sky Country. Join Mike as he reads from his best-loved book, *Montana Is…*, and his classic trilogy of cowboy poetry.
34 minutes, VHS, $15.95

Bronc to Breakfast & Other Poems

This poigant and powerful collection of cowboy poetry captures the essence of ranch life.
80 pp., 5 1/2" x 8 1/2", illus., (not pictured) $9.95 softcover

Bronc to Breakfast Audio Tape (not pictured) $9.95

Laugh Kills Lonesome & Other Poems

More cowboy poetry from the master storyteller.
80 pp., 5 1/2" x 8 1/2"., illus., (not pictured) $9.95 softcover

Laugh Kills Lonesome Audio Tape (not pictured) $9.95

Men of the Open Range & Other Poems

Mike's third collection of spirited Western verse.
80 pp., 5 1/2" x 8 1/2"., illus. $9.95 softcover

Men of the Open Range & Other Poems Audio Tape $9.95

Little Friends

In down-to-earth verse and photography, *Little Friends* celebrates the small, furry mammals of the American West. Great for kids of all ages!
32 pp., 9 1/4" x 8 1/4", 40 color photos, $9.95 softcover

Send your order for *Ranchin' Is…* and any of these additional titles to:

Buglin' Bull Press
32 S. Howie
Helena, Montana 59601